GLITCH
FEMINISM

GLITCH FEMINISM

A Manifesto

LEGACY RUSSELL

VERSO

London • New York

First published by Verso 2020
© Legacy Russell 2020

5 7 9 10 8 6

Verso
UK: 6 Meard Street, London W1F 0EG
US: 20 Jay Street, Suite 1010, Brooklyn, NY 11201
versobooks.com

Verso is the imprint of New Left Books

ISBN-13: 978-1-78663-266-1
ISBN-13: 978-1-78663-268-5 (UK EBK)
ISBN-13: 978-1-78663-269-2 (US EBK)

British Library Cataloguing in Publication Data
A catalogue record for this book is available from the British Library

Library of Congress Cataloging-in-Publication Data
A catalog record for this book is available from the Library of Congress

Cover design by Elizabeth Karp-Evans (Pacific)
Typeset in Sabon by Biblichor Ltd, Edinburgh
Printed and bound by CPI Group (UK) Ltd, Croydon CR0 4YY

For DIGITALMAN, who:

001—Loved me and my avatar.

002—Championed journeying along this gorgeous loop.

003—Died before this was born[e],
but who birthed me, and for that, birthed this, too.

Still processing, you live here, in these pages, with us all.

O, dear one we've lost, but who lives on, online.
For you, we write your name here, and occupy this space.

Say their name.
Say their name.
Say their name.

fuck
the whole muthafucking thing
Etheridge Knight, "Feeling Fucked Up," 1986

Contents

THESE ARE THE AXES:

1
BODIES ARE INHERENTLY VALID

2
REMEMBER DEATH

3
BE UGLY

4
KNOW BEAUTY

5
IT IS COMPLICATED

6
EMPATHY

7
CHOICE

8
RECONSTRUCT, REIFY

9
RESPECT, NEGOTIATE

Mark Aguhar, *These Are the Axes*, 2012

00 – INTRODUCTION

As a tweenager I logged on as LuvPunk12 and spent the following years wandering the highways of haunted machinery, occupying chat rooms and building GeoCities GIF fantasies. Growing up on Saint Mark's Place in the center of the East Village I learned how to construct and perform my gendered self from the punk kids I met on my stoop, from the drag queens who took the stage at Stingy Lulu's and dominated yearly at Wigstock in Tompkins Square Park, as well as from the Boricua culture, all of which was, at the time, part of the bedrock of the East Village and Lower East Side.

LuvPunk12 became a symbolic amalgam of all this flow. I chose the name when I spotted *LUV PUNK!* on a candy-apple-red heart-shaped sticker adhered to a phone booth outside of my apartment building. I was twelve. I peeled it off and stuck it to my Trapper Keeper, wearing it as a badge of pride. It became a rooted reminder of home as I transitioned in and out of spaces beyond the East Village that often felt alienating to me.

LuvPunk12 as a chatroom handle was a nascent performance, an exploration of a future self. I was a young body: Black, female-identifying, femme, queer.[1] There was no pressing pause, no reprieve; the world around me never let me forget these identifiers. Yet online I could be whatever I wanted. And so my twelve-year-old self became sixteen, became twenty, became seventy. I aged. I died. Through this storytelling and shapeshifting, I was resurrected. I claimed my range. Online I found my first connection to the gendered swagger of ascendancy, the thirsty drag of aspiration. My "female" transmogrified, I set out to explore "man," to expand "woman." I toyed with power dynamics, exchanging with other faceless strangers, empowered via creating new selves, slipping in and out of digital skins, celebrating in the new rituals of cybersex. In chatrooms I donned different corpo-realities while the rainbow wheel of death buffered in the ecstatic, dawdling jam of AOL dial-up.

Those dulcet tones of dial-up were Pavlovian: they made me salivate in anticipation of the worlds that lay just beyond the bells. I was a digital native pushing through those cybernated landscapes with a dawning awareness, a shyly exercised power. I was not yet privileged enough to be fully formed as cyborg but, in reaching, surely on my way.

And I was not alone.

Away from the keyboard (or "AFK"), immersed in a rapidly gentrifying East Village, faces, skin, identities like my own and like the mixed communities I had been brought up in were slowly disappearing. I was becoming a stranger in my own territory, a remnant of a past chapter of New York. Creative families of color like mine who had built the vibrant landscape of downtown New York were being priced out of the neighborhoods. Suddenly those living next door were increasingly white, upwardly mobile, and made visibly uncomfortable by my presence and the presence of my family. The "old guard" were coming up against a generation of trust-fund children. These new arrivals were intrigued by the mythology of the East Village as a cultural bastion yet displayed little interest in investing in the necessary fight to protect its legacy.

Beyond my doorstep, my queer femininity found itself, too, in a vulnerable passage through channels of middle school heteronormativity. My prepubescent body was exhausted by social mores, tired of being told to take up less space, being seen and not heard, systematically erased, edited out, ignored. All I wanted to do was move. But in the light of daytime, I felt trapped, always shifting uneasily under the weight of incessant white heteronormative observation.

Under this sort of surveillance, real innocence and childhood play seems suddenly unviable. Instead I searched for

opportunities to immerse myself in the potential of
refusal. I commenced to push back against the violence
of this unconsented visibility, to take control of the eyes
on me and how they interpreted my body. It was clear to
me, as I stood at a volatile intersection, that the binary
was some kind of fiction. Even for a fledgling queer Black
body, a DuBoisian double-consciousness splinters fur-
ther, "double" becoming "triple," consciousness amplified
and expanded by the "third eye" of gender.

Looking through these veils of race and gender but
never being fully seen myself, with limited reference
points in the world beyond, I was distanced from any
accurate mirror. For my body, then, subversion came via
digital remix, searching for those sites of experiment-
ation where I could explore my true self, open and ready
to be read by those who spoke my language. Online, I
sought to become a fugitive from the mainstream, unwill-
ing to accept its limited definition of bodies like my own.
What the world AFK offered was not enough. I wanted—
demanded—more.

The construct of gender binary is, and has always
been, precarious. Aggressively contingent, it is an imma-
terial invention that in its toxic virality has infected our
social and cultural narratives. To exist within a binary
system one must assume that our selves are unchange-
able, that how we are read in the world must be chosen

for us, rather than for us to define—and choose—for ourselves. To be at the intersection of female-identifying, queer, and Black is to find oneself at an integral apex. Each of these components is a key technology in and of itself. Alone and together, "female," "queer," "Black" as a survival strategy demand the creation of their individual machinery, that innovates, builds, resists. With physical movement often restricted, female-identifying people, queer people, Black people invent ways to create space through rupture. Here, in that disruption, with our collective congregation at that trippy and trip-wired crossroad of gender, race, and sexuality, one finds the power of the glitch.

A glitch is an error, a mistake, a failure to function. Within technoculture, a glitch is part of machinic anxiety, an indicator of something having gone wrong. This built-in technological anxiety of *something gone wrong* spills over naturally when we encounter glitches in AFK scenarios: a car engine calling it quits; getting stuck in an elevator; a city-wide blackout.

Yet these are rather micro examples in the broader scheme of things. If we step back further, considering the larger and more complicated systems that have been used to shape the machine of society and culture, gender is immediately identifiable as a core cog within this wheel. Gender has been used as a weapon against its own

populace. The idea of "body" carries this weapon: gender circumscribes the body, "protects" it from becoming limitless, from claiming the infinite vast, from realizing its true potential.

We use "body" to give material form to an idea that has no form, an assemblage that is abstract. The concept of a body houses within it social, political, and cultural discourses, which change based on where the body is situated and how it is read. When we gender a body, we are making assumptions about the body's function, its sociopolitical condition, its fixity. When the body is determined as a male or female individual, the body performs gender as its score, guided by a set of rules and requirements that validate and verify the humanity of that individual. A body that pushes back at the application of pronouns, or remains indecipherable within binary assignment, is a body that refuses to perform the score. This nonperformance is a glitch. This glitch is a form of refusal.

Within glitch feminism, glitch is celebrated as a vehicle of refusal, a strategy of nonperformance. This glitch aims to make abstract again that which has been forced into an uncomfortable and ill-defined material: the body. In glitch feminism, we look at the notion of *glitch-as-error* with its genesis in the realm of the machinic and the digital and consider how it can be reapplied to inform the way we see the AFK world, shaping how we might participate in it

toward greater agency for and by ourselves. Deploying the Internet as a creative material, glitch feminism looks first through the lens of artists who, in their work and research, offer solutions to this troubled material of the body. The process of becoming material surfaces tensions, prompting us to inquire: *Who defines the material of the body? Who gives it value—and why?*

These questions are challenging and uncomfortable, requiring us to confront the body as a strategic framework and one that is often applied toward particular ends. Yet, along this line of inquiry, glitch feminism remains a mediation of desire for all those bodies like mine who continue to come of age at night on the Internet. The glitch acknowledges that gendered bodies are far from absolute but rather an imaginary, manufactured and commodified for capital. The glitch is an activist prayer, a call to action, as we work toward fantastic failure, breaking free of an understanding of gender as something stationary.

While we continue to navigate toward a more vast and abstract concept of gender, it must be said that at times it really does feel, paradoxically, as if all we have are the bodies we are housed in, gendered or otherwise. Under the sun of capitalism, we truly own little else, and even so, we are often subject to a complicated choreography dictated by the complicated, bureaucratic, and

rhizomatic systems of institutions. The brutality of this precarious state is particularly evident via the constant expectation that we as bodies reassert a gender performance that fits within a binary in order to comply with the prescriptions of the everyday. As political scientist and anthropologist James C. Scott writes, "Legibility [becomes] a condition of manipulation."[2] These aggressions, marked as neutral in their banality, are indeed violent. Quotidian in nature, we find ourselves fending off the advances of binary gender as it winds its way through the basics of modern life: opening a bank account; applying for a passport; going to the bathroom.

So, what does it mean to dismantle gender? Such a program is a project of disarmament; it demands the end of our relationship with the social practice of the body as we know it. In his 1956 novel *Giovanni's Room*, writer and activist James Baldwin's protagonist David darkly muses, "It doesn't matter, it is only the body, [and] it will soon be over." Through the application of the glitch, we ghost on the gendered body and accelerate toward its end. The infinite possibilities presented as a consequence of this allows for our exploration: we can dis-identify and by dis-identifying, we can make up our own rules in wrestling with the problem of the body.

Glitch feminism asks us to look at the deeply flawed society we are currently implicated by and participating

in, a society that relentlessly demands we make choices based on a conceptual gender binary that limits us as individuals. Glitch feminism urges us to consider the *in-between* as a core component of survival—neither masculine nor feminine, neither male nor female, but a spectrum across which we may be empowered to choose and define ourselves for ourselves. Thus, the glitch creates a fissure within which new possibilities of being and becoming manifest. This failure to function within the confines of a society that fails us is a pointed and necessary refusal. Glitch feminism dissents, pushes back against capitalism.

As glitch feminists, this is our politic: we refuse to be hewn to the hegemonic line of a binary body. This calculated failure prompts the violent socio-cultural machine to hiccup, sigh, shudder, buffer. We want a new framework and for this framework, we want new skin. The digital world provides a potential space where this can play out. Through the digital, we make new worlds and dare to modify our own. Through the digital, the body "in glitch" finds its genesis. Embracing the glitch is therefore a participatory action that challenges the status quo. It creates a homeland for those traversing the complex channels of gender's diaspora. The glitch is for those selves joyfully immersed in the in-between, those who have traveled away from their assigned site of gendered

origin. The ongoing presence of the glitch generates a welcome and protected space in which to innovate and experiment. Glitch feminism demands an occupation of the digital as a means of world-building. It allows us to seize the opportunity to generate new ideas and resources for the ongoing (r)evolution of bodies that can inevitably move and shift faster than AFK mores or the societies that produce them under which we are forced to operate offline.

With the early avatar of LuvPunk12, I cloaked myself in the skin of the digital, politicking via my baby gender play, traveling without a passport, taking up space, amplifying my queer blackness. This experience of machinic mutiny was foundational to me, and gave me the courage to let go of the ambivalence that comes with fear of fossilizing in formation inherent to the upheavals of adolescence. I found family and faith in the future with these interventions, shaping my personal visions of a self that could be truly empowered in being self-defined, a futurity that social decorum regularly discouraged for a queer Black body.

Feminist writer and activist Simone de Beauvoir is famous for positing "One is not born, but rather becomes, a woman." The glitch posits: One is not born, but rather becomes, a body. Though the artifice of a simple digital Shangri-La—a world online where we could all finally be

"freed" from the mores of gender, as dreamt of by early cyberfeminists—is now punctured, the Internet still remains a vessel through which a "becoming" can realize itself. The glitch is a passage through which the body traverses toward liberation, a tear in the fabric of the digital.

This book is for those who are en route to becoming their avatars, those who continue to play, experiment, and build via the Internet as a means of strengthening the loop between online and AFK. This book will call on and celebrate artists who make critique of the body central to their practice, and share the hard fought-for rooms created on this journey as we seek shelter, safety, futurity. To quote poet, critic, and theorist Fred Moten, "The normative is the after-effect, it is a response to the irregular."

As glitch feminists, we inject our positive irregularities into these systems as errata, activating new architecture through these malfunctions, seeking out and celebrating the slipperiness of gender in our weird and wild wander. Toward this purpose, this book is structured in twelve sections, each section intended to pose an alternative after-effect, allowing us to peer through the lens of new practices and politics to discover new ways that life not only imitates, but begins with, art. Each of the twelve sections begins with a declaration, a white wall against which to cast glitch feminism in

its slip, side, and manifesto. This text will travel from an exploration of *glitch* as a word to its reapplication within the context of (cyber)feminism, to a history of cybefeminism itself, challenging who has been made most visible in these narratives. Each section will apply the concept of the glitch in an investigation, and celebration, of artists and their artwork that help us imagine new possibilities of what the body can do, and how this can work against the normative. Beginning online, we will journey the online-to-AFK loop, seeing how glitch feminism can be used out in the world at large, inspired by practitioners who, in their rebellion against the binary body, guide us through wayward worlds toward new frameworks and new visions of fantastic futures.

01 – GLITCH REFUSES

NOPE
(a manifesto)

I am not an identity artist just because I am a Black artist with multiple selves.

I am not grappling with notions of identity and representation in my art. I'm grappling with safety and futurity. We are beyond asking should we be in the room. We are in the room. We are also dying at a rapid pace and need a sustainable future.

We need more people, we need better environments, we need places to hide, we need Utopian demands, we need culture that loves us.

I am not asking who I am. I'm a Black woman and expansive in my Blackness and my queerness as Blackness and queerness are always already expansive. None of this is as simple as "identity and representation" outside of the colonial gaze. I reject the colonial gaze as the primary gaze. I am outside of it in the land of NOPE.

Consider artist E. Jane's 2016 piece *NOPE (a manifesto)*. I begin here, with the words of *NOPE*, because bound up within them is the foundational refusal required "to glitch." *To glitch* is to embrace malfunction, and to embrace malfunction is in and of itself an expression that starts with "no." Thus E. Jane's *NOPE* helps us take these first steps.

E. Jane writes:

I am not an identity artist just because I am a Black artist with multiple selves.

I am not grappling with notions of identity and representation in my art. I'm grappling with safety and futurity. We are beyond asking should we be in the room. We are in the room. We are also dying at a rapid pace and need a sustainable future.

We need more people, we need better environments, we need places to hide, we need Utopian demands, we need culture that loves us.

I am not asking who I am. I'm a Black woman and expansive in my Blackness and my queerness as Blackness and queerness are always already expansive. None of this is as simple as "identity and represent-ation" outside of the colonial gaze. I reject the colonial gaze as the primary gaze. I am outside of it in the land of NOPE.

Before talking about what glitch is or what it can do, let's meditate on the idea of a "[self] with multiple selves" and acknowledge that the construction of a self, creative or otherwise, is complex. E. Jane's naming and claiming of "multiple selves" pushes back against a flattened read-ing of historically othered bodies—intersectional bodies who have traveled restlessly, gloriously, through narrow spaces. These are the selves that, as writer and activist Audre Lorde wrote in her 1978 poem "A Litany for Survival," "live at the shoreline" and "were never meant to survive."

To seize "multiple selves" is, therefore, an inherently feminist act: multiplicity is a liberty. Within their crea-tive practice, E. Jane explores the freedom found in multiplicity, stretching their range across two selves: E. Jane and their "alter-ego" avatar Mhysa. Mhysa is a self-proclaimed "popstar 4 the underground cyber resistance" who crossed into some of E. Jane's early

artworks presented via the now-defunct "multimedia cultural hub" and "creation engine" NewHive.[1]

E. Jane's NewHive piece "MhysaxEmbaci-Freakinme" (2016) featured Mhysa in a pulsing field of lavender peonies, glittering lips, and moving bodies ever-so-slightly out of sync in the digital drag of a syncopated collage of sound and imagery. These two selves began as relatively distinct entities, with Mhysa "allowing [E. Jane] to be a part of [themselves that] white institutions tried to smother," serving as an alter-ego that self-recorded and shared snippets of their own blooming becoming on Instagram, Twitter, and Facebook.[2] Then, in 2017, Mhysa released an LP with eleven tracks aptly titled *Fantasii*, marking the moment when "the slippage between IRL and URL" deepened as Mhysa performed songs and sets AFK, stepping out into E. Jane's world and perforating the carefully constructed divide between on- and offline selfdom.[3]

E. Jane's journey toward Mhysa, first as an avatar and then as an AFK extension of themselves, is one marked by finding room to roam, and finding their range. I think of the poet Walt Whitman's 1892 poem "Song of Myself":

> Do I contradict myself?
> Very well then I contradict myself,
> (I am large, I contain multitudes.)

Whitman, a white man, was considered radically queer for his time. Within these lines of his, he captures a perfect snapshot of the problem of patriarchy, and of whiteness. Whitman is an agent bound up within a social and cultural status quo, yet that he "contain[s] multitudes" is his exercise of his right to be "large," his capacity to "contradict" himself is his exercise of the right to be blurry, unfixed, abstract. Patriarchy exercises its social dominance by taking up space as its birthright; when patriarchy comes into contact with whiteness, it leaves little room for anything else. Space is not just claimed by those exercising the "primary gaze" E. Jane speaks of, but is also made for them: space for becoming an unencumbered, range-full self and the agential complexity this provides is granted and protected for normative selves and the bodies they occupy.

What E. Jane fiercely protects—that expansive self—Whitman dons fearlessly, wholly unconcerned with the threat of having privilege taken from him. More than one hundred twenty years apart, they speak to each other through a void, yet look toward two very different worlds. When considering identity and the language often used to speak of it (e.g., "the mainstream" and those "at the margins"), it comes as little surprise that under white patriarchy, bodies—*selves*—that cannot be defined with clarity by the "primary gaze," are pushed

from the center. There, a Black queer femme body is flattened, essentialized as singular in dimension, given little room to occupy and even less territory to explore. As flat shadowy figures standing at the margins, we are stripped of the right to feel, to transform, to express a range of self.

The history of this sort of flattening or "othering" is one that has deep roots within a painful narrative of race, gender and sexuality in America, but also remains consistent across a world history of war. Where imperialism has touched, where neocolonialism continues, the force of flattening can be found. If one can render another body faceless and unrecognizable, if one can pin another as subhuman, it becomes easier for one group to establish a position of supremacy over another.

Violence is a key component of supremacy and, as such, a core agent of patriarchy. Where we see the limitation of a body's "right to range," be it at an individual or state level, we see domination.

E. Jane is not being hyperbolic when they write that we are "dying at a rapid pace." Pushed to the margins, we find ourselves as queer people, as people of color, as femme-identifying people most vulnerable in weathering world conditions, ranging from climate change to plantation capitalism. Thus, envisioning what shape a sustainable future might take, finding safe "places to

hide" in addition to techniques that provide space for ourselves, is urgent.

Glitch is all about traversing along edges and stepping to the limits, those we occupy and push through, on our journey to defining ourselves. Glitch is also about claiming our right to complexity, to range, within and beyond the proverbial margins. E. Jane is correct: we *do* "need places to hide, we need Utopian demands, we need culture that loves us."

The imaginative architecture of utopia remains ever present in glitch feminism. It gives us home and hope. In 2009, academic and queer theorist José Esteban Muñoz wrote in his *Cruising Utopia*, "Queerness is that thing that lets us feel that this world is not enough, that indeed something is missing."[4] In this "something missing" is desire, a wanting of a better world, a rejection of the here and now. Muñoz observes, "We have been cast out of straight time's rhythm, and we have made worlds in our temporal and spatial configurations."[5] A refusal of "straight time" and, via extension, of a Eurocentric model of time and space, E. Jane posits a NOPE that does not settle for a world or a social system that fails us.

The oblique romance of Internet-as-utopia, against this backdrop reality, should not be dismissed as naïve. Imbuing digital material with fantasy today is not a retro act of mythologizing; it continues as a survival

mechanism. Using the Internet to play, perform, explore still has potential. Giving ourselves this space to experiment perhaps brings us closer to a projection of a "sustainable future."

The same is true online as AFK. All technology reflects the society that produces it, including its power structures and prejudices. This is true all the way down to the level of the algorithm. The outmoded myth, however, that equates the digital and the radical continues to prove counterfeit. Normative cultural institutions and the social construct of taxonomical norms—gender, race, class—within them are quick to marginalize difference. Paradoxically, the very nature of these differences titillate, are labeled as "wild." Nevertheless, this wildness is permitted just as long as it is properly maintained, growing only within its prescribed space. Just as physical institutions lack intelligence and awareness, so do institutions of the digital—Facebook, Twitter, Instagram, Snapchat, TikTok. These are the institutions (re)defining the future of visual culture; they are also, without question, deeply flawed.

In the spring of 2018, in the midst of #MeToo, a Snapchat ad surfaced asking viewers if they would prefer to "slap Rihanna" or "punch Chris Brown," which resulted in a backlash of outrage about its making light of singer Rihanna's 2009 domestic abuse at the hands of

her then-partner, singer Chris Brown. High-profile individuals such as former rapper Joe Budden and media figure Chelsea Clinton voiced their support of Rihanna, and their general horror regarding the distasteful ad on Twitter. Rihanna herself went to Instagram, a rival to the Snapchat platform, to "talk back" to Snapchat, writing: "You spent money to animate something that would intentionally bring shame to DV victims and made a joke of it."[6] In the days that followed, Snapchat stock lost $800 million[7]. Rihanna exercised her own refusal, her nonperformance by stepping back from a Snapchat "public," an intervention in which she raised a fist in solidarity with survivors of domestic abuse.

The paradox of using platforms that grossly co-opt, sensationalize, and capitalize on POC, female-identifying, and queer bodies (and our pain) as a means of advancing urgent political or cultural dialogue about our struggle (in addition to our joys and our journeys) is one that remains impossible to ignore. At these fault lines surface questions of consent—yours, mine, ours—as we continue to "opt-in," feeding our "selves" (e.g., our bodies as represented or performed online) into these channels. To quote poet Nikki Giovanni: "Isn't this counter-revolutionary[?]"[8]

Perhaps, yes. However if we assume that Audre Lorde's 1984 declaration that "the master's tools will never

dismantle the master's house" still holds true, then perhaps what these institutions—both online and off—require is not dismantling but rather mutiny in the form of strategic occupation. The glitch challenges us to consider how we can "penetrate . . . break . . . puncture . . . tear" the material of the institution, and, by extension, the institution of the body.[9] Thus, hacking the "code" of gender, making binaries blurry, becomes our core objective, a revolutionary catalyst. Glitched bodies—those that do not align with the canon of white cisgender heteronormativity—pose a threat to social order. Range-full and vast, they cannot be programmed.

Glitched bodies are not considered in the process of programming new creative technologies. In 2015, Google's image-recognition algorithm confused Black users with gorillas. The company's "immediate action" in response to this was "to prevent Google Photos from ever labelling any image as a gorilla, chimpanzee, or monkey—even pictures of the primates themselves."[10] Several years later, Google's 2018 Arts & Culture app with its museum doppelgänger feature allowed users to find artwork containing figures and faces that look like them, prompting problematic pairings as the algorithm identified look-alikes based on essentializing ethnic or racialized attributes.[11] For many of us, these "tools" have done little more than gamify racial bias. These

technologies underscore the dominant arc of whiteness within art historical image-making and the dissemination of those images in a marketplace that presents deep biases of its own. They also highlight the structural inequality inherent to the creation of these tools themselves, with such algorithms created for and by whiteness, and so echo the exclusionary and violent art historical canon.

Online, we grapple with multiplying questions of use, participation, and visibility. Never before in history has there been such an opportunity to produce, and access, so many different types of publics. In 1995, poet and activist Essex Hemphill mused, "I stand at the threshold of cyberspace and wonder, is it possible that I am unwelcome here, too? Will I be allowed to construct a virtual reality that empowers me? Can invisible men see their own reflections?"[12]

Today Hemphill's questions endure, made even more complicated by the fact that the "public" of the Internet is not singular or cohesive but divergent and fractal. What's more, the "space" of cyberspace that Hemphill calls upon has shown itself not to be a universally shared utopia. Instead, it is a space with many worlds, and within these worlds, vastly different understandings of what utopia might look like or become—and for whom. The Internet is an immersive institutional edifice, one

that reflects and surrounds. There is no fixed entry-point: it is everywhere, all around us. Thus, the notion of Hemphill's "threshold" has since timed out.

This search for our "own reflections"—recognizing oneself within digital material and the electric black mirror that carries it—is bound up inextricably with a search for self-recognition away from the screen as well. Othered bodies are rendered invisible because they cannot be read by a normative mainstream and therefore cannot be categorized. As such, they are erased or misclassified within and outside of an algorithmic designation. Perhaps, then, this "land of NOPE" that E. Jane speaks of in their manifesto is the exact utopia Hemphill calls out for, that sacred ground where our digital avatars and AFK selves can be suspended in an eternal kiss. A land where we do not wait to be welcomed by those forces that essentialize or reject us but rather create safety *for* ourselves in ritualizing the celebration *of* ourselves.

With this, the digital becomes the catalyst to a variance of selfdom. With each of us "invisible men," we remain responsible for manifesting our own reflections, and through today's Internet, we can find ways to hold those mirrors up for one another. Thus, we are empowered via the liberatory task of seizing the digital imaginary as an opportunity, a site to build on and the material to build with.

Glitch manifests with such variance, generating ruptures between the *recognized* and *recognizable*, and amplifying within such ruptures, extending them to become fantastic landscapes of possibility. It is here where we open up the opportunity to recognize and realize ourselves, "reflect[ing]" to truly *see* one another as we move and modify. Philosopher and gender theorist Judith Butler observes in her *Excitable Speech: A Politics of the Performative*, "One 'exists' not only by virtue of being recognized, but . . . by being recognizable."[13] We delineate ourselves through our capacity for being recognizable; we become bodies by recognizing ourselves and, in looking outward, by recognizing aspects of our self in others.

Through Hemphill's musing on "reflections" in cyberspace, he makes plain the lack thereof within a broader social milieu, with the still-limited prevalence of such "reflections" both on- and offline. We will always struggle to recognize ourselves if we continue to turn to the normative as a central reference point. In a conversation between writer Kate Bornstein and trans artist, activist, and producer Zackary Drucker, Bornstein observed, "When gender is a binary, it's a battlefield. When you get rid of the binary, gender becomes a playground."[14]

The etymology of *glitch* finds its deep roots in the Yiddish *gletshn* (to slide, glide, slip) or the German *glitschen*

(to slip). *Glitch* is thus an active word, one that implies movement and change from the outset; this movement triggers error.

The word *glitch* as we now use and understand it was first popularized in the 1960s, part of the cultural debris of the burgeoning American space program. In 1962, astronaut John Glenn used the word in his book *Into Orbit*: "Another term we adopted to describe some of our problems was 'glitch.' Literally, a glitch . . . is such a minute change in voltage that no fuse could protect against it."[15] The word resurfaced some years later in 1965 with the *St. Petersburg Times* reporting that "a glitch had altered the computer memory inside the US spacecraft Gemini 6"; still again in the pages of *Time Magazine*: "Glitches—a spaceman's word for irritating disturbances."[16] Later, in 1971, "glitches" appears in an article in the *Miami News* about Apollo 14's failure to perform when a glitch had nearly botched a landing on the moon.

Traversing through these origins, we can also arrive at an understanding of glitch as a mode of nonperformance: the "failure to perform," an outright refusal, a "nope" in its own right, expertly executed by machine. This performance failure reveals technology pushing back against the weighty onus of function. Through these movements, technology does, indeed, get slippery:

we see evidence of this in unresponsive pages that present us with the fatalistic binary of choosing to "kill" or "wait," the rainbow wheel of death, the "Sad Mac" iconography, a frozen screen—all indicative of a fatal system blunder.

Herein lies a paradox: glitch moves, but glitch also blocks. It incites movement while simultaneously creating an obstacle. Glitch prompts and glitch prevents. With this, glitch becomes a catalyst, opening up new pathways, allowing us to seize on new directions. On the Internet we explore new publics, engage with new audiences, and, above all, *glitschen* between new conceptions of bodies and selves. Thus, glitch is something that extends beyond the most literal technological mechanics: it helps us to celebrate failure as a generative force, a new way to take on the world.

In 2011, the theorist Nathan Jurgenson presented his critique of "digital dualism," identifying and problematizing the split between online selfdom and "real life." Jurgenson argues that the term *IRL* ("In Real Life") is a now-antiquated falsehood, one that implies that two selves (e.g., an *online* self versus an *offline* self) operate in isolation from each other, thereby inferring that any and all online activity lacks authenticity and is divorced from a user's identity offline. Thus, Jurgenson advocates for the use of *AFK* in lieu of *IRL*, as AFK signifies a more

continuous progression of the self, one that does not end when a user steps away from the computer but rather moves forward out into society away from the keyboard.

The glitch traverses this loop, moving beyond the screen and permeating every corner of our lives. It shows us that experimenting online does not keep us from our AFK selves, nor does it prevent us from cultivating meaningful and complex collaborative communities beyond our screens. Instead, the polar opposite: the production of these selves, the digital skins we develop and don online, help us understand who we are with greater nuance. Thus, we use glitch as a vehicle to rethink our physical selves. Indeed, the body is itself an architecture that is activated and then passed along like a meme to advance social and cultural logic. Historically, feminism was built on this mired foundation, first advocating for parity yet paradoxically not always across all bodies, or without anti-sexist, anti-racist, anti-classist, homophobic, transphobic, and ableist aims central to its agenda. As a movement, the language of feminism—and, more contemporarily, "lifestyle feminism"—has in large part been codependent on the existence of gender binary, working for change only within an existing social order.[17] This is what makes the discourse around feminism so complicated and confusing.

*

Feminist theorist Donna Haraway's legendary 1984 construction of "the cyborg" within "A Cyborg Manifesto"—on which so many discussions of techno- and cyberfeminism have been built—complicates our understanding of bodies further. Haraway's cyborg actively argues away from the lexicon of the human, a classification that historically othered bodies (e.g., people of color, queer people) have long fought to be integrated into. Hindsight is 20/20: Haraway in 2004 looked back on her manifesto, noting, "A cyborg body is not innocent . . . we are responsible for machines . . . Race, gender, and capital require a cyborg theory of wholes and parts."[18]

In 1994, cultural theorist Sadie Plant coined the term "cyberfeminism." As a historical project and as ongoing politics, cyberfeminism remains a philosophical partner to this discourse on glitch: it looks to online space as a means of world-building, challenging the patriarchal normativity of an "offline mainstream." Yet the early history of cyberfeminism mirrored the early history of AFK feminism in its problematic reapplication of first- and second-wave feminist politics within what at that point was a third-wave feminist culture well underway.

Early cyberfeminists echoed early AFK first-wave feminist rhetoric in being phobic of transnational allyship. The public face of cyberfeminism was regularly

championed and fetishized as one of white woman-hood—Sadie Plant, Faith Wilding, N. Katherine Hayles, Linda Dement, to name a few pioneers—and found dominant support within the realm of art school academia. This reality demarcated digital space as both white and Western, drawing an equation: *white women = producing white theory = producing white cyberspace.*

This white cyberfeminist landscape marginalized queer people, trans people, and people of color aiming to decolonize digital space by their production via similar channels and networks. Exceptions such as the Old Boys' Network, SubROSA, or the VNX Matrix were impactful in offering up alternative discourse that recognized peripherally racism alongside sexism, but the hypervisibility of white faces and voices across feminist cyberculture demonstrated ongoing exclusion, even within this new, "utopic" setting.

Despite this, those early days of cyberfeminism lay important groundwork in introducing the technological, the digital, even the cybernetic as a computational imaginary to mainstream feminism. With cyberfeminism, feminists could newly network, theorize, and critique online, transcending (if only temporarily, if only symbolically) sex, gender, geography. With this also came a foundational awareness of how power operates as an agent of capitalism within the edifice of online space, spurred

forth by technological builders who shape how we as users experience digital worlds and their politics.

Feminism is an institution in its own right. At its root is a legacy of excluding Black women from its foundational moment, a movement that largely made itself exclusive to middle-class white women. At the root of early feminism and feminist advocacy, racial supremacy served white women as much as their male counterparts, with reformist feminism—that is, feminism that operated within the established social order rather than resisting it—appealing as a form of class mobility. This underscores the reality that "woman" as a gendered assignment that indicates, if nothing else, a right to humanity, has not always been extended to people of color.

Feminist "sisterhood" toward the purpose of increasing white range and amplified social, cultural, economic mobility, is an exercise in service of supremacy—*for white women only*. This is the ugly side of the movement: one where we acknowledge that while feminism is a challenge to power, not everyone has always been on the same page about who that power is for and how it should be used as a means of progress. *Progress for whom?* Thus, American abolitionist, women's right activist, and freed slave Sojourner Truth's question "Ain't I a woman?" asked in 1851 continues to be painfully resonant even today, surfacing the ever-urgent reality of who is brought

into the definition of womanhood and, via extension, who is truly recognized as being fully human.

As we wade our way through contemporary feminisms and the negotiations of power embodied by #BlackLives Matter, #MeToo, or the tradition of the Women's March, we must recognize that these movements are defined and driven by technology, harbingers of a promising and potentially more inclusive "fourth wave" unfolding on the horizon. Still, the dangerous vestiges of first- and second-wave histories linger on. Writer, activist, and feminist bell hooks may have declared that "feminism is for everybody," but what remains is still a long and winding road ahead until we get there.

Where *glitch* meets *feminism* in a discourse that problematizes the construct of the body, it is important to call out the historical construction of gender as it intersects with a historical construction of race. The body is a social and cultural tool. Because of this, the right to define what a body is, in addition to who can control these things called "bodies," has never been meted out equally. In a contemporary landscape where the term "intersectional" is bandied about with such ease, it is important to acknowledge the work of blackness in particular toward the project of feminism.

Sojourner Truth's urgent inquiry can also shine light on the queer body across a spectrum of identification.

In a contemporary setting Truth's line of inquiry calls for the recognition of humanity and a future that celebrates bodies of color, bodies that femme-identify, bodies that embrace the in-between and beyond, all as an active resistance, a strategic blur of binary. We cannot forget: it was, and continues to be, the presence of blackness that aided in establishing a primary precedent for the notion of intersectionality within feminism. *Intersectionality* as a term was coined in 1989 by theorist and activist Kimberlé Crenshaw to speak to the realities of blackness and womanhood as part of a lived experience, neither half exclusive of one another, but rather advancing the work of both sides. Crenshaw's enduring contribution bolsters the foundation for the early thinking that drove making space for multiplicity across selves within a broader social and cultural context, one that resonates today both online and AFK alike.

As German artist and cyberfeminist Cornelia Sollfrank observes: "Cyberfeminism does not express itself in single, individual approaches but in the differences and spaces in-between."[19] It is in the space between that we as glitch feminists have found our range, our multiple and varied selves. Thus, the work of blackness in expanding feminism—and, by extension, cyberfeminism—remains an essential precursor for glitch politics, creating new

space and re-defining the face of a movement, amplifying the visibility of historically othered bodies.

We can find examples of this in texts such as writer Octavia Butler's 1980s *Xenogenesis* trilogy, which galvanizes the notion of a third sex futurity that defies binary gender. Or Audre Lorde's discussion of the erotic as power in her 1978 paper "Uses of the Erotic: The Erotic as Power," which encourages us to discover our full range through a self-connection that delivers joy. These contributions did not rise up out of cyberfeminism, but they have transformed, expanded and liberated it. Such alchemy makes limitless the capacity of glitch to mobilize.

Let us revisit, occupy, and decolonize Whitman's words in our call for refusal:

> Do I contradict myself?
> Very well then I contradict myself,
> (I am large, I contain multitudes.)

02 – GLITCH IS COSMIC

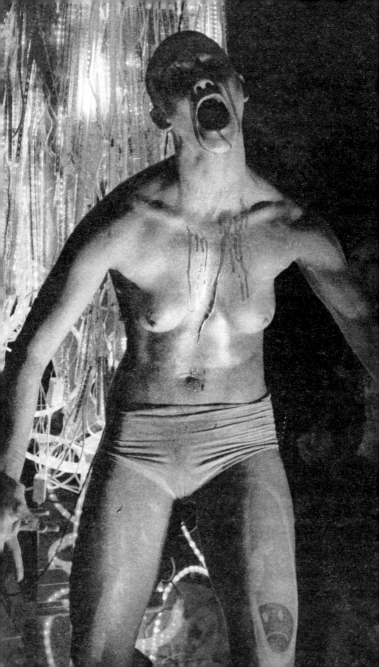

When we are all stardust, we will say the media distorts
 the public's perception of cosmic bodies.

. . . I'm not opaque. I'm so relevant I'm disappearing.

—Anaïs Duplan, "On a Scale of 1–10,
How 'Loving' Do You Feel?"

There are many ways to think about the body. When poet, artist and curator Anaïs Duplan speaks of "cosmic bodies" he advances a unique turn. This cosmic corporality provides exciting insights into how we might approach the body as an architecture. When we consider glitch as a tool, it is useful to consider how this tool can help us better understand the body also as an idea.

The body is an idea that is cosmic, which is to say, "inconceivably vast." Though evidence of human life leading up to the Anthropocene spans 2.6 million years and running, we have only just begun to scratch the surface of what the body is, what it can do, what its future looks like.

Body: it is a world-building word, filled with potential, and, as with *glitch*, filled with movement. *Bodied*, when

used as a verb, is defined in the Oxford Dictionary as "giv[ing] material form to something abstract." Noun and verb alike, we use *body* to give form to abstraction, to identify an amalgamated whole.

We all begin in abstraction: ungendered but biologically sexed bodies that, as we develop, take on a gendered form either via performance or according to constructs of social projection. To dematerialize—to once more abstract—the body and transcend its limitations, we need to make room for other realities.

The Internet is "a room of one's own."[1] Art critic Gene McHugh in his essay "The Context of the Digital: A Brief Inquiry into Online Relationships" observes, "For many people who came of age as individuals and sexual beings online, the internet is not an esoteric corner of culture where people come to escape reality and play make-believe. It *is* reality."[2] Thus, the term "digital native" has been applied to the generation who remembers nothing other than a life intertwined with the Internet.

McHugh notes video and performance artist Ann Hirsch's two-person play "Playground" (2013) as an example of such negotiations of play, reality, and sexuality on the Internet. Hirsch's play explores her relationship as a pre-teen digital native with an older man online, during a period of time when the world offline failed to provide enough stimulus for Hirsch's freeform emotional,

sexual, and intellectual exploration. While complicated in its dynamic, the relationship fostered between the two online opened up new pathways in enriching Hirsch's understanding of her body and its politic.

The application of the online-versus-IRL dichotomy in the discussion of gender or sex play online is deeply flawed. Such limits are bound up within a construct of "real life," one that violently forecloses worlds, rather than expands them. IRL falters in its skewed assumption that constructions of online identities are latent, closeted, and fantasy-oriented (e.g., *not* real) rather than explicit, bristling with potential, and very capable of "living on" away from the space of cyberspace. Instead, AFK as a term works toward undermining the fetishization of "real life," helping us to see that because realities in the digital are echoed offline, and vice versa, our gestures, explorations, actions online can inform and even deepen our offline, or AFK, existence. This is powerful.

Thus glitch feminism gives weight to the selves we create through the material of the Internet. Glitch feminism makes room for realizing other realities, wherever one might find oneself. As part of this process, an individual is not only inspired to explore their range online, but also can be moved to quite literally embody the digital as an aesthetic, blurring the divide between body and machine further. The creative AFK application of a

machinic aesthetic vernacular onto the physical form presents a uniquely performative turn.

Performance artist boychild exemplifies this, embodying what artist and writer James Bridle has called "the New Aesthetic" in her blending of the virtual and the physical across her creative practice. A term coined by Bridle in 2012, the New Aesthetic is cited as "a way of seeing that . . . reveal[s] a blurring between 'the real' and 'the digital,' . . . the human and the machine."[3] boychild performs robotically, often nude, in trademark drag- and Butoh-inspired lip-sync performances, a glowing light emanating from the artist's painted mouth. This staged work nods to the history of cybernetics and the dawn of the Internet, while simultaneously evoking the tactility of queer nightlife.

In a conversation with artist and co-collaborator Wu Tsang, boychild explains, "Nightlife is important for my work because it creates a space for me to exist; nothing contextualizes my performance the same way as these places do. It's my world, my existence in the underground. Also, I exist in a world that comes after the Internet . . . my adolescence was spent finding things there. The underground exists on the Internet for me."[4] boychild draws a connection between the "underground" of nightlife spaces, those spaces that allow for experimentation and exploration of new identities, and the Internet as

playground, serving a similar purpose. This underscores the role of Internet-as-cabaret, where avant-garde performance, such as boychild's work, both begins with and borrows from digital culture. Significantly, as we can look at the 1990s as a moment marked by the rise of digital culture and cyberfeminism and a simultaneous increase in the systematic erasure of spaces catering to queer nightlife across major cities internationally.[5]

boychild's performances raise questions about body-as-machine and how non-binary affect can be negotiated and expressed—computed, even—via machinic material. boychild observes of this practice, "It's like the physical body turning into a cyborg . . . It's like a glitch; there's a repetitive thing that happens. It's moving slow, but also fast."[6] Via this cyborgian turn, the artist intentionally embodies error, a sort of system-seizure that borrows from the machine in an AFK resistance.

The passage of glitched bodies between the Internet underground and an AFK arena activates the production of new visual culture, a sort of bionic patois fluent to the digital native. Suspended between on- and offline, eternally traversing this loop, digital natives steeped in a reality shaped by the New Aesthetic remain devoid of a homeland. There is no return to the concept of "the real," as digital practice and the visual culture that has sprung from it has forever reshaped how we read, perceive,

process all that takes place AFK. This digital diaspora therefore is an important component of glitch, as it means that bodies in this era of visual culture have no single destination but rather take on a distributed nature, fluidly occupying many beings, many places, all at once.

Writer, poet, philosopher and critic Édouard Glissant defines diaspora as "the passage from unity to multiplicity," exploring these "departure[s]" within a selfdom as being plausible only when "one consents not to be a single being and attempts to be many beings at the same time."[7] Glitch feminism reapplies Glissant's "consent not to be a single being," making an appeal toward the cosmic range wherein a personal and collective dispersion toward vastness becomes a consensual abstraction.

What theorist Lisa Nakamura calls "tourism" in *Cybertypes: Race, Ethnicity, and Identity on the Internet*, described as "the process by which members of one group try on for size the descriptors generally applied to persons of another [group]," remains a limitation to how we process the role of the digital as it relates to identity.[8] Nakamura's notion of Internet identity as largely touristic plays into a digital dualist fallacy. Investing in a cosmic becoming, glitch feminism views these acts of experimentation as pathways toward a blooming of selfhood. Perhaps, though begun initially under the somewhat faceless anonymity of online platforms, the opportunity to

experiment and try on different selves empowers seizing a more integrated public identity with radical potential.

I think here of CL[9], a young feminist who produces zines as part of her creative practice, who in conversation shared with me that her early use of online platforms like LiveJournal and, years later, Twitter, encouraged her to test the grounds and prove herself *to* herself within a public arena by toying with language, humor, and representation and seeing how such things were received by others. At first she saw the opportunity to "hide race for a while" and "just be" on these platforms; the vast facelessness of digital space provided a neutrality that boosted her confidence as she began to see that her fierce wit, feminist politics, and perspectives on the world were welcomed by an online public. CL notes that it was via the Internet that she embraced her identity as "an intelligent Black girl," a perception of herself that found its genesis first online and was then taken AFK with greater individual purpose, community support, and holistic understanding.

The glitched self is always on the move. This diasporic journey of online to offline is a mode of parthenogenesis, reproducing oneself without fertilization—splitting, merging, emerging. This is the rubric for an embodied political technology that queers proudly, creating space for new bodies and cosmic selves.

03 – GLITCH THROWS SHADE

The meteoric rise to cultural acclaim and recognition of self-defined "cyborg" and artist Juliana Huxtable, in recent years, is important and timely. Within the realms of art, music, literature, fashion, she seeks to shatter the rigidity of binary systems. Raised in College Station, Texas, Huxtable was born intersex and assigned to the male gender. During the 1990s, in a moment where the Internet and the mythology of its utopia was on the rise, Huxtable male identified, going by the name Julian Letton.

In a conservative Texan, Christian milieu, claiming a trans identity seemed unimaginable. Yet when she left home to attend small liberal arts Bard College in upstate New York, she entered a period that marked a blooming in her sense of self, one she speaks about openly: "I was fully brainwashed by the Bible Belt shit . . . but the Internet became a form of solitude. It gave me a sense of control and freedom that I didn't have in my everyday life, because I walked through life feeling hated, embarrassed, trapped, and powerless. I felt very suicidal."[1]

As her art practice expanded, Huxtable's engagement with various digital platforms—chatrooms, blogs, social media, and beyond—increased the visibility of both her visual and written work, creating the opportunity for it to circulate both within and beyond the contemporary art world. At the same time, images of Huxtable herself circulated mimetically. A GIF travels virally online, emoting via the eternal loop of digital affect, quoting Huxtable's reaction to the question, "What's the nastiest shade ever thrown?" to which she replies, "Existing in the world."

The 2015 New Museum Triennial in New York City brought the power of Huxtable's creative presence to new heights. Huxtable's nude body in repose was the subject of artist Frank Benson's 3D-scanned plastic sculpture *Juliana*. Benson's statue is an homage to Huxtable and a "post-Internet response to the . . . Grecian sculpture *Sleeping Hermaphraditus* . . . like that ancient artwork, Huxtable's naked pose reveals body parts of both sexes."[2] Benson makes contemporary his take on this classic, with Huxtable leaning on one arm, the other extended in a yogic "mudra" hand gesture, and the figure painted a metallic green.

In the gallery space, Benson's sculpture of Huxtable was positioned adjacent to four inkjet prints of Huxtable's

own work. This included two self-portraits and two poems as part of Huxtable's 2015 series "Universal Crop Tops For All The Self Canonized Saints of Becoming." The titling of the series hearkens a celebration of transformation, of becoming, signifying a cosmic journey toward new, more inclusive canons and, by extension, selves. The self-portraits, respectively titled "Untitled in the Rage (Nibiru Cataclysm)" and "Untitled (Psychosocial Stuntin')" (both 2015), show the artist in Nuwaubian Nation avatar, painted in one portrait in a neon violet and in the other an alien green. The artist's poems accompanying the portrait prints wander through past, present, and future, awash with technicolor meditations on a wide range of topics: climate change, COINTELPRO, Black reparations, sainthood. In these texts Huxtable calls forth Octavia Butler, Angela Davis, Aaliyah, and the "hood surrealism" of Hype Williams, who directed many of the music videos of 90s-era Black pop and R&B stars.

In a conversation with artist Lorraine O'Grady, Huxtable reflects on the experience of showing her work—and her body, via Benson's sculpture—in the Triennial:

I had a growing sense of anxiety . . . Performance offered a powerful way to deal with questions of

self-erasure or presence, tempting an audience with the idea that I am performing to enable their consumption of my image or my body—and then to ultimately refuse that. Text and video and all of this media become modes of abstracting presence or abstracting myself in the present. And so right now performance feels like a way of dealing with the sort of aftermath of a cultural moment.[3]

Huxtable's exercise in "abstracting presence or abstracting myself" as a mode of performativity—between online and AFK—intersects with glitch feminism's cosmic ambitions to abstract the body as a means of reaching beyond its conventional limitations. In her celebrity, Huxtable regularly exercises a "necessary visibility," electing to make her cosmic body visible through ongoing documentation of herself online, most notably via Instagram.[4] She explains, "the Internet and specifically social media, became an essential way for me to explore inclinations that I otherwise would not have an outlet for."[5]

For Huxtable, as with many others using online space as a site to re-present and re-perform their gender identities, the "Internet represents . . . a 'tool' for global feminist organizing . . . [and] an opportunity to be protagonist . . . in [one's] own revolution." It is also a "'safe space' . . . a way to not just survive, but also resist,

repressive sex/gender regimes"[6] and the antagonistic normativity of the mainstream.

Huxtable herself is a glitch, and a powerful one at that. By her very presence Huxtable throws shade: she embodies the problematics of binary and the liberatory potential of scrambling gender, embracing one's possible range. Such cosmic bodies glitch, activating the production of new images that "create . . . [a] future as practice of survival."[7] The glitch is call-and-response to Huxtable's declaration of being, that "shade" of "existing in the world," enduring as the "nastiest" form of refusal.

In a dystopic global landscape that makes space for none of us, offers no sanctuary, the sheer act of living—surviving—in the face of a gendered and racialized hegemony becomes uniquely political. We choose to stay alive, against all odds, because our lives matter. We choose to support one another in living, as the act of staying alive is a form of world-building. These worlds are ours to create, claim, pioneer. We travel off-road, away from the demand to be merely "a single being." We scramble toward containing multitudes against the current of a culture-coding that encourages the singularity of binary.

Glitching is a gerund, an action ongoing. It is activism that unfolds with a boundless extravagance.[8] Nonetheless, undercurrent to this journey is an irrefutable tension: the

glitched body is, according to UX (user experience) designer, coder, and founder of collective @Afrofutures_ UK Florence Okoye, "simultaneously observed, watched, tagged and controlled whilst also invisible to the ideative, creative and productive structures of the techno-industrial complex."[9]

We are seen and unseen, visible and invisible. At once error and correction to the "machinic enslavement" of the straight mind, the glitch reveals and conceals symbiotically.[10] Therefore, the political action of glitch feminism is the call to collectivize in network, amplifying our explorations of gender as a means of deconstructing it, "restructuring the possibilities for action."[11]

In the work of London-based artist and drag queen Victoria Sin we can see this restructuring inhabited. Assigned female at birth, Sin identifies as non-binary and queer, a body that amplifies gender in their re-performance of it, both online via Instagram and AFK. On stage—whether out in the world or wrapped within the seductive fabric of the digital—Sin toys with the trappings of gender. Sin's drag personae remain pointedly high femme, the different selves they perform under-scoring the socio-cultural production of exaggerated femininity as a gendered trope, ritual, and exercise.

Sin dons gender as prosthesis. An homage to an expans-ive history of masculine/feminine drag performance and

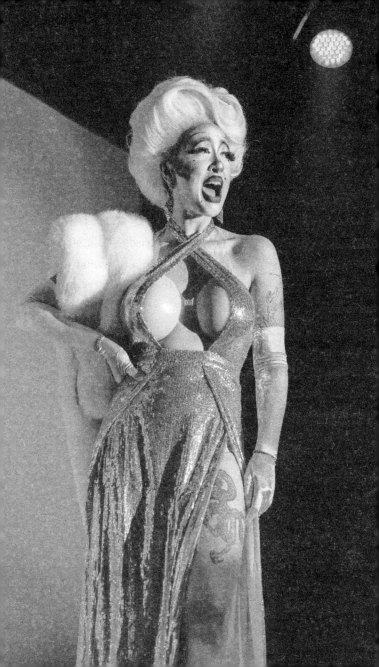

genderfucking, Sin's costumery is replete with breast and buttocks inserts, a sumptuous wig, makeup painted with vivid artistry and a sweeping gown that glitters. Sin's aesthetic is an evocative, mesmeric cocktail, that weaves with satire and expertise the sensory swagger of cabaret, buzz of burlesque, vintage Hollywood glamor— all with a dash of Jessica Rabbit.

AFK, Sin's performances as drag avatar and alter-ego take up space with exaggerated curve, contour, and composition that femme-identifying bodies are often forced to relinquish. This is a striking reminder that the production of gender is, at best, an assemblage. It is surreal, in the sense of a dream, and "full of other bodies, pieces, organs, parts, tissues, knee-caps, rings, tubes, levers, and bellows."[12] Online via Instagram, Sin occupies a pop vernacular akin to YouTube makeup tutorials, deliberately exposing the seams of their gender-prep by sharing video and photographs of what typically would be labor left unseen. In the highly stylized presentation of their constructed selfhood, we see Sin becoming their avatar through the gloss of digital drag, where the Internet offers the space of cyber-cabaret. Sin stitches together *before* and *after* imagery of themselves as they put on their "face," with cutting commentary and humor that inspires awe and prompts inquiry about how we read bodies, and why. In these gestures, Sin is super-human, extra-human, and

post-human all at once. Sin also celebrates "woman" as trapping and as trap, the trickery of gender itself underscored as a thirsty-AF agent of capitalism, at points gently divine yet still violently disorienting.[13]

Sin themself is a glitch and, in glitching, throws shade. Their body shatters the shallow illusion of any harmony or balance that might be offered up within the suggestive binary of male/female. Sin's hyperfemininity is a send-up and glorification. They play with and challenge what philosopher and gender theorist Judith Butler identifies as "a male in his stereotype . . . a person unable to cope with his own femininity" as well as the inverse, holding a mirror up to the female stereotype, as, perhaps, a body "unable to cope with" her masculinity.[14]

In this vein, Sin's model of coping is complex. On the one hand, Sin's drag erases the material body via the amplification of gendered artifice, reducing it to near ridicule and undermining any assumption of gender as absolute. On the other hand, Sin's drag points toward the dilemma of the body itself by celebrating their queer body as necessarily visible, fantastically femme, larger than life, and so extreme in its existence that it becomes impossible to ignore, a calculated confrontation, vast in impact.

Sin's shade is a skin: protective but permeable, and an exciting rendering of what the future of body politic

might look like as something emancipatory in its intentional error. Here we see a crack in the gloss and gleam of capitalist consumption of gender-as-product. Here each half of the binary is eating the other, a dazzling feat to feast on. As glitch feminists, we join both Huxtable and Sin here in a "reach toward the ineffable."[15] Through refusal, we aim to deconstruct and dematerialize the idea of the body as we move through time and space, as wild forms building toward even wilder futures.

04 – GLITCH GHOSTS

Imagine being useless.

—Richard Siken, "Seaside Improvisation"

By definition, "to ghost" is to end a relationship by ending all communication, and subsequently disappearing.

As glitch feminists, we want to ghost the binary body.

Gender is a scaled economy: it is a mode of regulation, management, and control. It allows for the reification of process, the division of labor, and the exchange of value under the umbrella of capitalism. In order to ghost on the binary body, to abandon it as a failed idea, we must step back and look at the world as a body, an assemblage that has been constructed. The body, like the world, is a tool in and of itself.

Ghosting on the binary body is a threefold process:

First, it requires us to realize that the relationship between the *idea of the body* and *gender as a construct* is a damaging one that we need to exit.

Second, it requires us to identify that we have agency either to consent or refuse our current "relationship status." Too often we forget that *we have the right to leave if we want to*. We have the right to deny our use, and, through this, close the wounds created by a world fed on the binary rhetoric.

Third, it requires us to claim our continuous range of multitudinous selves. As we fail to assimilate into a binary culture, we do so by asserting all components of ourselves—the masculine, the feminine, and everything in-between—as being part of a continuous narrative, rather than existing as polar points.

The scaling of the economy of gender features most prominently across discussions surrounding "big data." For example, every forty-eight hours online we as a global community generate as much information as was generated in written history from the beginning of civilization until 2003.[1] This data we generate triggers monumental questions about mass surveillance and how the information tied to our digital selves can be used to track our every movements. Our Internet search histories, social media habits, and modes of online communication—what sociologist David Lyon calls "factual fragments"—expose our innermost thoughts, anxieties, plans, desires,

and goals.[2] Gender binary is a part of this engine: a body read online as male/female, masculine/feminine fulfills a target demographic for advertising and marketing. Google Ads explains gleefully to its users, "With demographic targeting in Google Ads, you can reach a specific set of potential customers who are likely to be within a particular age range, gender, parental status, or household income. For instance, if you run a fitness studio exclusively for women, demographic targeting could help you avoid showing your ads to men."[3]

Lyon identifies "disappearing bodies" as a "basic problem of modernity," citing that the increase of surveillance correlates directly with the "growing difficulties of embodied surveillance that watches visible bodies." This is not always restricted to the easy monitoring of a physical self but also comes from the tracking of "personal traces"[4] such as when we use our bank cards, the scraping of our travel data, our mobile phone signals. Lyons's concept of disappearing bodies speaks to the reality of an increasingly networked world, where online exchange and interaction is now just as, if not more, common than physical AFK interaction. On the Internet we go to the bank, we pay our student loans, we speak to our friends, we read news and learn about the world.

With these various modes of online engagement, we leave traces of ourselves scattered across the digital

landscape, vulnerable to be tracked and traded for profit. This presents a darkly modern paradox: as bodies disappear within the everyday interactions of the Internet, that which we might have assumed as inherently private—our physical bodies—remain at risk of becoming increasingly public, the abstracted fragments of our online selves making moves independent of those chosen of our own volition.

How can ghosting on the binary body help us keep safe our factual fragments as we fight to maintain our abstract bodies, our cosmic selves?

There is a long legacy to the attempts to split the body into autonomous parts. However, glitch feminism demands that we look at it another way, through the vision of another ghost—the ghost in the machine. The continuity between online and AFK selfdom problematizes the proposition of digital dualism. With this in mind, we can deepen our understanding of digital dualism further by reaching back to the idea of "the ghost in the machine," a term coined in 1949 by the philosopher Gilbert Ryle.

The *ghost in the machine* presupposed that the mind and body were somehow separate entities, operating autonomously. Those critical of this position pointed out that the "ghost" of our minds ought not to be made distinct from the "machine" of our physical selves, as the

loop between the two is a crucial component of what makes us human—it is what gives us life. Artist Cécile B. Evans "argues that in today's society, where drones are used for warfare and romantic relationships begin online, we can no longer distinguish between the so-called real and the virtual."[5]

As the body in its contemporary context and the machines it engages become increasingly difficult to splice, this offers an opportunity to see that the machine is a material through which we process our bodily experience. And, as such, bodies navigating digital space are as much computational as they are flesh. Still, the movement of our data within a gendered economy is not self-determined. In the world we live in today, a body that refuses binary is one that is regularly reminded that, standing in-between, it is at threat of ceasing to exist in its failure to be recognized and categorized by the normative hegemony of the mainstream.

What is a body, therefore? Artist and writer Rindon Johnson ponders this in his 2019 essay "What's the Point of Having a Body?" asking: "What's the point of having a body if I theoretically could make or step into so many?"[6] Johnson reflects on the "malleable" self as a form of language that can teach, learn, signify, code. Johnson, a poet himself, creates a link between poetry and virtual reality as virtual reality maps to the body's

experiential immersion within it: "The more you are inside of [virtual reality], the more you read it, the easier it is to quickly disappear within it."[7]

Perhaps, then, as we work toward ghosting the binary body, we also work toward dissolving ourselves, making the boundaries that delineate where we begin and end, and the points where we touch and come into contact with the world, disappear completely. In this, perhaps our factual fragments can be scrambled, rendered unreadable. If existence within a hegemonic culture today requires the gender binary to delineate the self and even to be recognized as human, then is ceasing to exist within a gendered framework the most skillful of disappearing acts? In rejecting binary gender, can we challenge how our data is harvested, and, in turn, how our data moves? *Can we become useless, too?*

The question of "What is a body?" as it intersects with our musing on how we might ghost on the binary body, presents itself as a *question of becoming*. In becoming, we shape-shift, deepen, evolve, as we leave the edifice of a gendered architecture. Thus, our movement—our ability to ghost on the idea of the body, moving away from it—is a key component of becoming. The movement of ghosting creates a generative void that makes space for new alternatives. *Becoming* prompts questions of who we are, who we would like to be, and triggers a spatial interrogation

of boundaries and how we might break through them. It brings us as well to explore the experience of touch in ways that might transform us. Black feminist theorist and critic Hortense Spillers notes, "The question of touch—to be at hand without mediation or interference—might be considered the gateway to the most intimate experience and exchange of mutuality between subjects . . . [it is] the absence of self-ownership."[8]

This "absence of self-ownership" *is* the consent to not be a single being, an embrace of a cosmic corporeality. The digital experience is defined by a touch that breaks limits; it "is not a non-existent reality, because we live it, feel it, can be changed by it."[9] As we engage with the digital, it encourages us to challenge the world around us, and, through this constant redressing and challenging, change the world as we know it, prompting the creation of entirely new worlds altogether.

When we reject the binary, we reject the economy that goes along with it. When we reject the binary, we challenge how we are valued in a capitalist society that yokes our gender to the labor we enact. When we reject the binary, we claim uselessness as a strategic tool. Useless, we disappear, ghosting on the binary body.

05 – GLITCH IS ERROR

manuel arturo abreu
@Deezius

please unfollow if reparations for black americans is not
the first thing on ur list of US political goals not interested
in responses thx

4:28 AM · Jun 29, 2014 · Twitter Web Client

18 Retweets **122** Likes

Excuse, names like teethmarks

—Yusef Komunyakaa, "Fever"

A glitch is an error. Glitches are difficult to name and nearly impossible to identify until that instant when they reveal themselves: an accident triggering some form of chaos. On- and offline, the boxes we tick, the forms we complete, the profiles we build—none are neutral. Every part of ourselves we mark with an *X*.

Every time we elect to have the form autofill the next time around, we participate in an act of naming, the process of identifying ourselves within highly networked social and cultural algorithms. We are standing inside the machine and every day we make a choice whether or not to rob ourselves. We banally are complicit with the individual theft of our own personal data. This is poised to become one of the greatest shared existential crises of our time.

The body is a text: every time we define ourselves, we choose definitions—names—that reduce the ways our bodies can be read. This is bittersweet, a gorgeous proposition that often ends tragically. The things that

make our lives "easier"—when our favorite digital plat-
form appears to know us better than we know ourselves,
suggesting an app in an ad that promises to save us
money, make us friends, bring back lost time—are the
same things that perpetuate a gendered binary. The
machine readily anticipates the cultural detritus and
vernacular that stems from the weight of a pronoun
and feeds us the perfect dress or shoe, even when we
don't want it.

Errors, ever unpredictable, surface the unnameable,
point toward a wild unknown. To become an error is to
surrender to becoming unknown, unrecognizable, un-
named. New names are created to describe errors,
capturing them and pinning down their edges for exam-
ination. All this is done in an attempt to keep things up
and running; this is the conceit of language, where people
assume if they can find a word to describe something,
that this is the beginning of controlling it.

But errors are fantastic in this way, as often they skirt
control, being difficult to replicate and therefore difficult
to reproduce for the sake of troubleshooting them out of
existence. Errors bring new movement into static space;
this motion makes an error difficult to see but its inter-
ference ever present. Decolonizing the binary body
requires us to remain in perpetual motion; accidental
bodies that, in their error, refuse definition and, as such,

defy language. Forcing the failure of words, we become impossible. Impossible, we cannot be named.

What is a body without a name? An error.

To disappear between ticked boxes, to fail at forms, to throttle the predictability of auto-play: we need to examine the act of naming and the role it plays in reifying gender as it is produced, packed, and delivered. When we stand in-between the boxes, things start to slip and slide; we begin to disappear. This state of opacity is a ripe error to reach toward, an urgent and necessary glitch.

Florence Okoye reminds us: "The unseen can manipulate the recursive behavior of [the machine], forcing automata to regurgitate, amplify, and perpetuate the glitch through the exponential reaches of the network."[1] Thus, by the seizure of our uselessness, we make the reading of our bodies more difficult. Wandering in-between, we become dangerous data. In this happy failure, we reconstitute reality.

In their poem "A PIECE OF WRITING THAT WON ME $200 IN EIGHTH GRADE," writer, poet and artist manuel arturo abreu muses:

I am a hyperlink, a flag for a fake country. You look at me and tell me what I am. I become what you name me. I carry these becomings. I am not male. You name

me male. I am not Other. You name me Other. I carry
all the names I'm given.[2]

We really do "carry all the names [we're] given," even
when we don't want them. Across the years of Luvpunk12
as my online avatar, AFK I naively bound and unbound
my breasts with duct tape, wondering if maybe what was
and was not visible there would help me circumnavigate
and escape the "suffer[ing that comes] from the condition
of being addressable," of being called, defined, named.[3]

At home I walked around without a shirt on feeling
empowered, until one day my father looked at me sharply
then turned to my mother, inquiring, "Does Legacy have
breasts now? Where did *those* come from?" Suddenly
there was something across my chest. Those two small
hills now like two new moons, furthering the violent
thesis of girlhood. In that moment I wished I could disap-
pear, cease to exist.

Was this being woman? But instead of disappearing, I
chose to take up space. In the same death to my range
that came by way of this act of marking, naming me,
came a challenge: *be vast, keep thriving, self-define.*

Yes, as abreu observes, *we are indeed hyperlinks*, signs
and signifiers waiting to be clicked through, decoded,
consumed. When we name bodies in an effort to make
them useful, we end worlds, a process of codifying and

delineating territory, limiting the capacity of the world around us and our agency within it. We can embody error by finding new ways to self-define, reclaiming the act of naming for ourselves. We bend the act of naming, fitting new forms through the process of naming and re-naming, the embrace of a poetic elasticity that refuses the name as static or definitive. Embodying error—an all-consuming joyful failure within a system that never wanted us and that will not make space for us if we simply wait for it—pushes the structures of the gendered binary further toward a breaking point. Inside of this beatific brokenness and as we travel beyond it, we ask: *What's next? Where to go from here?*

Artist and theorist micha cárdenas explores the poet-ics of trans people of color in digital media, and the possibilities for acts of resistance as deployed through algorithmic restructure. In her 2019 essay "Trans of Color Poetics: Stitching Bodies, Concepts, and Algorithms," cárdenas points toward writers and academics Sarah Kember and Joanna Zylinska and the discussion of what they dub "the cut" in their book *Life After New Media*, as an entry-point for cárdenas's analysis of what she calls "the stitch."[4] For Kember and Zylinska, "the cut" is "a creative in-cision that is also a de-cision, because it gives shape to the world."[5] The authors recognize the act of cutting—the splicing of a single entity into discrete parts

or creating a split where formerly there was solely a whole—as an "intrusion of alterity (e.g., "difference")."[6] Kember and Zylinska propose that the sheer tension created in the presence of such "intrusion[s] of alterity" shock the larger hegemonic system and triggers the possibility of individual action or perhaps even broader structural change.

Conversely, cárdenas's "stitch" is conceived of as "an operation that involves using one entity to connect two formerly separate entities," which she suggests is perhaps "less violent than the cut" as it "intends to join, in the service of healing and creation, rather than in the service of destruction."[7] In consideration of the stitch and its broader social and cultural resonance, cárdenas notes that it can be thought of as the "basis for a theory of feminist making, which values the forms of knowledge practiced daily by oppressed people as they make their lives in the face of violence."[8]

Thus, if the act of gender-defining as dictated by the binary cuts deeply, it is our *self-definition* that manifests the stitch, begins the process of healing. This is the error, this is the glitch: incessant cutting and stitching, breaking and healing, as it is afforded by the digital as performative material within the context of the everyday. New configurations of the body posited and performed daily across the online-to-AFK loop enact a mass corrective edit to a

history that has far too long canonized fit, straight, cisgender, white, male bodies. This, indeed, is a shock to the system happening now at an unprecedented volume and scale.

Artist and writer Sable Elyse Smith in her 2016 essay "Ecstatic Resilience" describes the "slippage" of a body across, through, beyond, the binary as a "walking through as opposed to being rested in . . . [a] pendulum sway from form to void."[9] Remaining in motion via our own self-transformation, together we "walk through" the injury of naming into a celebratory occupation of a body that refuses fixity. Unnamed and useless, failing fantastically, we remain "porous bodies" in our pathway toward liberation.[10] Endlessly, we reboot, revive, scroll, survive.

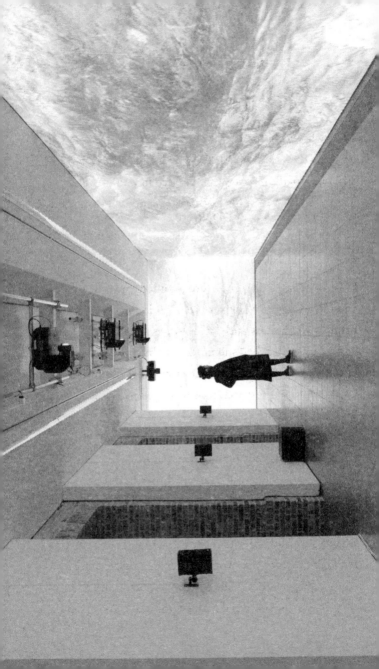

The whole concept of visibility assumes that you're not in a system that wants you dead. I think a lot of people forget that many of the places we are inserted in want to kill us . . .

We're not supposed to be there.

—Sondra Perry[1]

Gender is, to call on a term coined by philosopher Timothy Morton, a "hyperobject."[2] It is all-encompassing, it out-scales us. As such, it becomes difficult to see the edges of gender when submerged within its logic, thereby bolstering the fantasy of its permanence through its apparent omnipresence. In short, gender is *so big*, it becomes invisible.

This is where the problem lies: in the invisibility that becomes seemingly organic. This "normative ordinary" is a violence, suggesting a natural order in lieu of a most unnatural system of control. In asserting itself as part of a vast normative ordinary, gender embeds itself within what we see and experience in the everyday, winding itself through the public networks and spaces that we live in.

As a hyperobject, gender becomes a geopolitical territory. It is a foundational framework, built and lived on.

Unable to see its edges, we are forced to live within it as a world in and of itself. This is why, in order to reimagine the body, one must reimagine space. Revolutionary change manifests through a reconsideration of the spatial, in negotiation of spatial limitations and identification of how to overturn, dissolve, break through these boundaries. Therefore, deterritorialization of the body requires a departure from the heaviness of space, with the realization, instead, that physical form is dynamic.

Philosopher and sociologist Henri Lefebvre writes, "The body serves both as point of departure, and as destination."[3] The body, thus, is an inspiration, a springboard, a conceptual catalyst, carrying us away from it as we travel through it. Immersed within the hyperobject of gender, it becomes important to figure out ways to signify its edges and folds, those cuts and stitches that point to the failures of what is assumed to be the natural world around us, aiding our departure from it.

Encryption is useful here as we search for those departure destinations, those moments where peeling back the layers of our presumptions reveals things hidden just below the surface. Encryption, as a process, indicates the encoding of a message, rendering it unreadable or inaccessible to those unauthorized to decipher it. To consider glitch as a form of encryption, we render the *plaintext* of the body (e.g., the body viewed through a normative,

binary lens) as *ciphertext* (e.g., a glitched body, queered and encrypted). Encryption offers a mode of privacy; encoding of content creates secure passageways for radical production. Glitches as encrypted (machinic, social, cultural) material remind "us that there are gaps and hidden histories, parts of the . . . file that . . . cannot [be] heard and stories . . . [that] will never [be] know[n]" to certain audiences.[4] Through this encryption, the glitch creates a new vernacular, one that allows for new modes of signification and is smuggled through the hyperobject of our hyper-gendered daily lives.

The (de)coding of gender becomes as much about how it is constructed as whether it can or cannot be read. Readability of bodies only according to standard social and cultural coding (e.g., to be white, to be cisgender, to be straight) renders glitched bodies invisible, extends safety, keeps bodies un-surveilled. Glitched bodies pose a very real threat to social order: encrypted and unreadable within a strictly gendered worldview, they resist normative programming. Illegible to the mainstream, the encrypted glitch seizes upon the creation of a self that, depending on the audience, can at once be hypervisible and simultaneously unreadable, undetectable.

This experience of being hypervisible and invisible all at once can be vulnerable. Artist Glenn Ligon's work "Untitled (I Feel Most Colored When I am Thrown

Against a Sharp White Background)" (1990) speaks to this blurriness, and its vulnerability. A text-based work that prints and reprints the words of its title in black block lettering against a white background, Ligon's words take different form as they progress, as they bleed between letters, becoming increasingly difficult to decipher.[5] It is a meditation on the limits of language. This work, these words, as they deteriorate, illustrate in their very form the violence that comes with the strict delineation of self-hood, of the body, when processed in contrast with another. Ligon's work highlights the problem of space and territory; distinguishing that which *is* via that which *is not* is a binary process of categorization that strips away humanity, leaving us all bare.

Artist Sondra Perry's exhibition *Typhoon coming on*, debuted as a site-specific installation at London's Serpentine Gallery in 2018, immersed the viewer in a surround projection of waves, the water and title in reference to British artist J. M. W. Turner's painting "Slave Ship (Slavers Throwing Overboard the Dead and Dying, Typhoon Coming On)" (1840). Turner's painting was inspired by the massacre of 130 African slaves by the British crew of the slave ship *Zong* in 1781. Using Blender, an open-source 3D graphics program, Perry applied a tool called Ocean Modifier to animate Turner's aqueous brushstrokes into a template of the ocean. The

projection, as one stands before it, flicks between waves rendered in the yellow ochres and grays of Turner's original palette, and a slick purple, signifying the presence of the artist's hand as author and editor of this work. The color purple within the Blender program is a glitch and, in turn, an encrypted signifier, an indicator to the user that, in the artist's words, "there is a missing texture or material . . . a warning to a maker . . . [that] something is missing."[6]

Thus, the piece exists as a corrective historical error, a uniquely feminist coding of Black narrative and the bodies therein, gesturing toward the edges of stories both hidden and untold, the intergenerational trauma that was seeded in the massacre's wake. Reflecting on this piece, Perry notes, "I'm interested in thinking about how blackness shifts, morphs, and embodies technology to combat oppression and surveillance throughout the diaspora. Blackness is agile."[7]

This "shift[ing], morph[ing], and embody[ing]" of technology as a means of pushing back against an exploitative hypervisibility is essential. The readability of glitched bodies in their choreography and topography, as they travel the terrain of the online-to-AFK loop is volatile. Responsive to world conditions, we remain intentionally erratic, always morphing and thus always unmapped. The information hidden by encryption

becomes key, edges peeled back solely for those meant to see, process, understand.

Elsewhere, we remain unreadable. To glitch the body requires the simultaneous occupation of *some-where* and *no-where*, *no-thing* and *every-thing*. We consent not to be a single being frozen in binary code, and, as such, consent as well not to be a single site. This embrace of multiplicity is strategic; as glitched bodies travel outward through every space, we affirm and celebrate the infinite failure of arrival at any place. Far beyond fixity, we find ourselves in outer space, exploring the breadth of cosmic corporeality.

We cannot allow these territories of *some-where, no-where, no-thing, and every-thing* to be delineated by the mainstream. Supremacy will not relinquish its space, those imagined sites building toward worlds of hyper-objects that, hyper-gendered, aim to erase us. We, the glitch, will encrypt. Only as refusal will our data continue to perform, transform, transmute, transmogrify, travel.

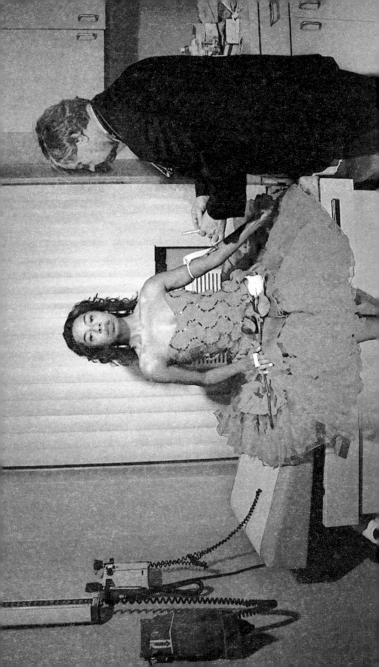

In the body, where everything has a price,
I was a beggar.

—Ocean Vuong, "Threshold"

Glitch is anti-body, resisting the body as a coercive social and cultural architecture. We use *body* to give form to something that has no form, that is abstract, cosmic. Philosopher Jean Luc-Nancy puts it perfectly: "Does anyone else in the world know anything like 'the body'? It's our old culture's latest, most worked over, sifted, refined, dismantled, and reconstructed product."[1] A lot of work is put into trying to give the body form.

Artist and filmmaker Lynn Hershman Leeson's notion of the "anti-body," as introduced in her 1994 essay "Romancing the Anti-body: Lust and Longing in (Cyber)space," lays useful groundwork for thinking of glitch as a mode of resistance against the social, cultural framework of the body.[2] "Like computer viruses," Leeson writes, anti-bodies "escape extinction through their ability to morph and survive, exist in perpetual motion, navigating parallel conditions of time and memory."[3]

The glitch thus advances Leeson's "anti-body" as a tactical strategy. This strategy becomes operable in the face of the failure of the systematized networks and the frameworks within which we build our lives. Glitches gesture toward the artifice of social and cultural systems, revealing the fissures in a reality we assume to be seamless. They reveal the fallibility of bodies as cultural and social signifiers, their failure to operate only as hegemonic normative formulations of capital weaponized by the state. The binary body confuses and disorients, pitting our interests against one another across modalities of otherness. State power in this way positions us all as foot soldiers at the frontlines of a most dangerous tribal war. We can do better.

The current conditions of the world, however flawed, ought not to preclude glitched bodies from the right to use imagination as a core component of mobilizing and strategizing with care toward a more sustainable futurity. Leeson observes, "the corporeal body [as we have known it] is becoming obsolete. It is living through a history of erasure, but this time, through enhancements."[4] Glitched bodies rework, glitch, and encrypt traces of ourselves, those new forms of personal digital data left behind. As the understanding of what makes up a "possible" body changes under this pressure, the information associated with our physical forms, now abstracted, changes, too.

We can see example of *anti-body* in the fictional character and "it girl" Miquela Sousa, known via her Instagram personality Lil Miquela. Lil Miquela was launched as a profile in 2016; however, it was not until 2018 that Lil Miquela claimed the identity of a sentient robot. Created by an LA-based company called Brud with the aspiration of becoming a prototype of "the world's most advanced AI," Lil Miquela is described by the Brud Team as "a champion of so many vital causes, namely Black Lives Matter and the absolutely essential fight for LGBTQIA+ rights in this country. She is the future." Yet, Lil Miquela has no body.

We wonder: *What purpose can a body that has no body serve?* In the face of an increasingly privatized world, can a corporate avatar—in essence, a privatized body, symbolic in form—be an authentic advocate, a catalyst toward social change?

Lil Miquela's Instagram profile advances the archetype of the influencer, capitalizing on the heightened visibility by using the platform to promote key political causes. Any given day, one might find shout-outs to @innocenceproject, @lgbtlifecenter, or @justiceforyouth on her profile. On the one hand, it could be argued that Lil Miquela epitomizes a perverse intersection of a neoliberal consumer capitalism and advocacy; on the other, she, being AI and therefore "without" a body,

epitomizes what becomes possible with avatar performativity. She is a newfangled opportunity to make visible the invisible, to weirdly engage with new audiences, to push the limits of corporeal materiality and reconsider how we might (re)define the body as we have always known it.

The work and life of artist Kia LaBeija furthers our exploration of *anti-body* as a vehicle within glitch feminism. LaBeija, who is Black and Filipino, is a queer woman living with HIV. Born Kia Michelle Benbow, the surname "LaBeija" derives from the legendary House of LaBeija, founded in either 1972 or 1977 (the exact year remains a point of contention) by the house's original mother, the drag queen Crystal LaBeija. The structure of "houses," intended to operate as chosen family units, is a survival strategy in itself, creating space for historically othered bodies. These important spaces are long-fought-for and celebrated epicenters of performance, nightlife, and queer culture. Houses compete against one another in voguing battles, a practice that originated in Harlem in the 1970s and has since grown into a well-recognized global phenomenon. Though she is no longer a member of the House of LaBeija, LaBeija in her own creative practice employs vogue dancing as well as storytelling and photography, self-documenting and self-defining a core component of her creative expression.

LaBeija in her very existence is a living legacy of the HIV and AIDS movement. The artist explains, "I was born in 1990, and medication that put you on a regimen that was expected to save your life didn't come around until, like, 1996, so people weren't sure babies with HIV of my age would survive."[5] Born nine years after the official start of the AIDS epidemic, LaBeija "complicates [the] idea of what a long-term survivor looks like."[6] LaBeija engages the practice of voguing in public space, her dancing a form of resistance and celebration, an embodiment of queer histories, and a decolonization of what the artist has called "a gay, white man's story."[7] In circulating self-portrait documentation of herself over years, LaBeija carries forth the torch of HIV and AIDS activism that was first lit in the 1980s by groups such as ACT UP and Gran Fury, who created new modes of visual culture and representation to alter the discourse surrounding bodies affected by HIV and AIDS.

In her self-portraits, LaBeija performs both *as* herself and *beyond* herself as an avatar, no longer Kia Michelle Benbow as she was born, but now in the "greatest role of all" as LaBeija.[8] Her sharply theatrical compositions blur the boundary between the real and surreal. In "Eleven" (2015), LaBeija photographs herself in her doctor's office, wearing her high-school prom dress, a decadent crush of tulle and lace in stark contrast with the sterile reality of a

regular routine of health maintenance and HIV care. In this image LaBeija performs the ritual of dressing up for prom, engaging in the American fantasy of having one night before graduating where a teenager can live out one's most epic dreams. Reflecting on this image, LaBeija notes: "I'm wearing my prom dress because when I first began to see [my primary physician], no one knew if I would make it to prom."[9] In "Mourning Sickness" (2014) LaBeija features herself somberly resting on the bathroom floor, yet illuminated with a pale light that amplifies the aqueous colors of the shower curtain, bathmat, and mirror. The lighting lends to the portrait a staged feel, giving it drama in its cinematic texture. LaBeija has said of this portrait: "[This image] tells the story of the many hours I've spent in my bathroom, lying on the floor feeling dizzy or nauseous because of the violent medications that I have to take every day. It also evokes locking myself in the bathroom and grieving for my mother's passing. I still deal with these feelings, and probably always will."[10] LaBeija, by way of her creative practice and advocacy work, gestures toward a long lineage of folx that worked hard to make space, take up space, and explore their range.

LaBeija's embrace of her history is a marked "consent not to be a single being": the artist's work demonstrates the complexity of her range, her portraits "express[ing]

08 – GLITCH IS SKIN

LOOKING INTO THE MIRROR, THE BLACK WOMAN ASKED, "MIRROR, MIRROR ON THE WALL, WHO'S THE FAIREST OF THEM ALL?" THE MIRROR SAYS, "SNOW WHITE YOU BLACK BITCH, AND DON'T YOU FORGET IT!!!"

Glitch is, and will always be a methodology for me . . .
I still really FEEL that brokenness and instability.

—Shawné Michaelain Holloway[1]

Skin is as much about what is kept in as what it keeps out.
It functions to edit, its existence determining that which
will be included or excluded. Skin suggests the protection
of a subject and the creation of an "other" that is forever
standing on the outside. As skin wraps, covers, protects,
it paradoxically wounds, occupies, and builds worlds.

Skin is a container. It is a peel that contains and cradles
wildness. It gives shape to bodies. A break, tear, rupture,
or cut in skin opens a portal and passageway. Here, too, is
both a world and a wound.

Skin is both open and closed. Its presence suggests
permanence, a border not meant to be crossed. Conversely,
skin is permeable. It releases fluids and, at the same time,
retains them.

Skin also helps us feel. When pressed against another,
we recognize where we end and where another begins.
In touching skin, we program the body, messy lines of
memory that lead us toward each other and cause

bodies to collide, sometimes gently, sometimes with a crash.

Most literally within a technological arc, the presence of a glitch makes the "digital skin" visible, reminding us of the fallibility of the machine and a presence of its hardware, revealing its edges and seams. We rely on the error of glitches to show us the machinic limitations and, in turn, to get a sense of where we might hack further in pointed undoing. Through a more figurative lens, the presence of error offline—as an unrecognizable body, a body without a name—reveals cracks in the seemingly glossy narrative of the absolute fixity of gender binary, exposing it as a carefully constructed fiction.

In these breaks and system failures, we find new beginnings. The digital skin—the screens through which we embrace range, politic via play, and toy with different modes of representation—remains a necessary precondition of the Internet avatar. Avatars can become rhetorical bodies, ones that challenge how and why we perform our abstract and varied selves toward the goal of becoming our truer selves, both on- and offline.

Self-described "dirty new media performance artist and sexuality educator" Shawné Michaelain Holloway's explorations as a "cam girl" inspires much of her early work. The artist grapples with the tensions between a projection of an invulnerable self with a seemingly

impenetrable digital skin, and the vulnerability of sharing oneself in such forums. Holloway readily exploits and navigates these tensions, leaning into newly realized freedoms found through her enacting fantasy selves online. The artist sees the volatility between these tensions and freedoms as an opportunity to engage conversations around power and play, investigating how a body can simultaneously, mutually, consensually consume and be consumed as a radical act of self-discovery. Holloway observes: "Power dynamics affected this work not because of the power of the people or the culture inside, but the power of the people and the culture outside looking in. I feel ashamed that I see these spaces as a playground where I get to construct my own fantasies and control my environment."[2]

Holloway triggers these same tensions in her 2015 series of Instagram portraits *picking skin: alignment*. The series is inspired by artist Carrie Mae Weems's 1987 photo work "Mirror, Mirror" from the *Ain't Jokin'* series (1987–1988) that depicts a Black woman looking into a mirror and with its caption riffing on the legendary line from the fairytale of Snow White, "Mirror, mirror on the wall, who's the finest of them all?" For *picking skin: alignment*, Holloway presents what she calls "pick[ed] skin[s]": selfie-style images of the artist enacting different performed personae into the "black mirror" of digital

capture. Through these images the artist establishes a micro-archive of her own cosmic corporeality; the varied faces of blackness and queerness are mediated by the digital skin of Holloway's changeable avatars.

In one set of images, the artist snaps a photo of herself donning a long blond wig, triggering the visual economy of the Internet cam girl, digital-diva-meets-fairytale-vixen, posing for the camera's anxious gaze. In contrast, another image shows the artist striking a pose without the wig but short, natural hair. In Weems's original series, the line "Mirror, mirror . . ." is re-appropriated and re-contextualized such that the mirror talks back to the Black woman in the portrait. The text accompanying each of Holloway's selfies therefore borrows nearly verbatim from Weems's original caption, changing Weems's word choice of "finest" back to the Snow White fairytale's original "fairest": "LOOKING INTO THE MIRROR, THE BLACK WOMAN ASKED, 'MIRROR, MIRROR ON THE WALL, WHO'S THE FAIREST OF THEM ALL?' THE MIRROR SAYS, 'SNOW WHITE YOU BLACK BITCH, AND DON'T YOU FORGET IT!!!'" Here Holloway makes plain the transience and trouble of the digital skin, signifying the action of self-representation (e.g., "putting on" different skins toward performing different selves) as still subject to the perforation of a pop visual culture and art history that enacts violence upon the Black femme

body by affirming models of aestheticized white beauty as foremost.

Although Holloway's work was not intended as such, we can certainly celebrate her series as a very necessary and sharp contestation to artist Amalia Ulman's five-month Instagram performance, "Excellences & Perfections" in 2014. Ulman's performance deployed an avatar of herself—a white cis-gendered woman—blending seamlessly via the digital skin of an online persona, situated within a landscape of mainstream representations of white, cisgender, high-femme bodies. The performance was scripted by the artist and presented across several months on her Instagram and Facebook, following her avatar as a white socialite. The blur between Ulman's "excellences [and] perfections" on- versus offline made this as a performance a jagged pill to swallow: Ulman did not disrupt or provide substantive feedback to the status quo, but rather her performance, basic as ever, reveled in it. The artwork thus became an unfortunate flaunting of privilege, haunted by a sort of socioeconomic "passing" that went unquestioned by a public accustomed to the gourmandized consumption of the superrich. Few looking at Ulman's Instagram could tell the difference between art and life, and so the work itself—confirming that, yes, white femme ascendancy still had an audience—was only made profound by the artworld calling it so.

Years later in May 2018, *New York* magazine's *The Cut* published a story on the "Soho grifter" who, calling herself Anna Delvey online and AFK, performed the identity of a wealthy German heiress with the goal of scamming luxury Manhattan hotels and billionaire acquaintances.[3] Whether Delvey was aware of Ulman's performance or not, the parallels between the two acts in their use of an online avatar to further cultivate public perception of elite status is undeniable. If anything, it was the world's coming into awareness of Delvey that may have completed Ulman's work, making plain the violence of privilege with its capitalist agenda, and the exploitation and manipulation of white femininity as a cultural asset and long-protected political trope. In short, what both artists—con or otherwise—show us is that gender cannot be left untroubled as *just* a construct, but rather that one of the biggest troubles of gender is that it is a racial construct.

If Ulman upheld the staid and troubled tropes of "bubblegum feminism" in her projections of a gendered white body packaged and consumed for cultural capital, Holloway offers an incisive and urgent fourth-wave perspective. Holloway does important work in shaking to the core the contradictions in how gendered and racialized bodies are "read" or rendered (in)visible by various publics on the Internet.

Holloway's strategic invocation of Weems also recognizes the act of Black self-representation in photographic portraiture as being part of a deeply rooted discussion surrounding visibility, empowerment, and the circulation of the Black body as simultaneously hindered, and driven by, the engine of visual culture. In Holloway's words, such bodies are weighted with the "fucked up political connotations that are attached to these desires," which manifest themselves through popular folklore, fairytale, or fantasy. Holloway calls her interest in "control and power over [her] representation [online]" a "fantasy-fetish," underscoring the implausibility of ever being able to fully dictate or refuse how one's body can and cannot be digested through the digital platform.[4]

The paradoxical nature of the digital skin worn by the artist posits a narrative of the queer Black body online that is neither exalted nor abject. Rather, the artist is empowering the curious and joyful navigation of these complicated and irreconcilable territories as a sort of "anarchitecture,"[5] putting up resistance through the self-chronicling of one's own unresolved and oft-contradictory shapeshifting.[6] In this way, Holloway strikes back at the social-cultural edifice of the gendered and racialized body. Her work offers relief from the undue burden of striving for perfection that is built to undermine and erase glitched bodies.

The safe passage of bodies AFK continues to be determined by race, class, and the legibility of one's gender. This volatility of the offline landscape where physical harm—and the systematic ending of life—is regularly enacted on bodies that do not "fit" makes it important to consider how to create safer spaces both on- and offline, working against the present necropolitical narrative. While online spaces remain imperfect, often holding a somber mirror up to the world around us, online communities can create space to talk back to toxic, binary tropes of masculinity/femininity. Embracing the plausibility of range—that is, fantasizing, playing, experimenting by donning different "skins"—becomes an act of empowerment, self-discovery, and even self-care. The skin of cyberidentity is uniquely queer, what theorist Paul B. Preciado even goes so far as to celebrate as a "form . . . of transvestism."[7] The digital, in giving us the capacity to perform different selves—quite literally putting them on, then taking them off, as we grow with or away from them—shows us that, as Preciado puts it, "Gender is not simply and purely performative [but rather that] . . . gender is first and foremost prosthetic."[8]

09 – GLITCH IS VIRUS

gender is a magic trick i forgot how to
perform

—Billy-Ray Belcourt, "The Cree Word for a Body Like
Mine is Weesageechak"

What can we learn from a computer virus? A computer
virus corrupts data. A computer virus costs capitalism. It
degrades productivity within the machine. A computer
virus is a threat to the function of the machine and its
economy. A machine transforms into one that cannot
perform, that quite literally *cannot work*, *forgets how to
work*, *works against its function*. It challenges the
endemic correlation between value and labor, dangerous
in its uselessness.

Machines are expected to work well and work quickly.
A computer virus triggers the machinic responses of
slowness in ways that are unpredictable to the user:
endless buffering, crashing, damaging, deleting, reform-
atting. This slowness shifts time and space, altering a
person's relationship to the machine. In our daily life
when confronted with a computer that shuts down unex-
pectedly or takes ages to reboot as a result of machinic

failure, our reaction is to get up and move. We change course when confronted with systems that refuse to perform.

A virus breaks, and so we are delivered into the time and space of brokenness. Inevitably, the presence of a virus shakes us into an awareness of our bodies and being. The presence of a virus prompts an awakening. This comes through the recognition that the loop between online and AFK is not seamless. Rather, through its fissures and faults, the virus makes brokenness a space, placing us within the break itself. As glitch feminists, when we embody the virus as a vehicle of resistance, we are putting a wrench into the machinic gears of gender, striking against its economy, immersing ourselves inside of brokenness, inside of the break.

We want to infect, to corrupt ordinary data. To quote theorist and philosopher Jack Halberstam, known for his concept of "the queer art of failure": "What we want after 'the break' will be different from what we think we want before the break and both are necessarily different from the desire that issues from being in the break."[1] What glitch feminism proposes here then is this: perhaps we want the break, we want to fail. We strive for oozing, challenging bodies full of seams. We want wild, amorous, monstrous bodies. Through our presence as a glitch, we want to stand before, within, and

outside of brokenness. The break an error, the error a passageway.

Once we have infected, we want to travel outward in every direction. We want to touch everything, caress *every-fucking-body*, twist the machine. Viral, we want to multiply. We want to cramp culture, make society sweat. We want to cause seizure, a rush of fluids, create sticky, runny spaces where everything can come into contact and blur. That blur is a beginning again, a journey. That journey is a genesis.

In Stefano Harney and Fred Moten's 2013 text *The Undercommons*, Moten argues: "The only thing we can do is tear this shit down completely and build something new."[2] Glitch feminism asks: *Can a break be a form of building something new? Can our breaking shit be a correction, too?*

The artist American Artist calls out to this notion of brokenness in their 2017 essay "Black Gooey Universe."[3] The essay revisits the origin story of graphical user interfaces (or GUIs, pronounced "gooeys") as a site to be problematized, one that establishes a binary of white digital interfaces as the indicator of modern transparency with black interfaces posited as outdated and opaque. These are signifiers of design choices and the history of white, cisgender drivers behind them. Artist peels back this logic, positing the "black gooey" as a useful erratum with revolutionary potential:

Blackness has, so to say, formed the ground for white, with black gooey being antithetical to the values of the white screen. Black gooey might then be a platform of slowness ("dragged time," "colored time"), refusal, thought, complexity, critique, softness, loudness, transparency, uselessness, and brokenness. A planar body that longs for the solitude and vastness of the command-line, yet nuanced and sharp, to usurp and destroy a contemporary hegemonic interface.[4]

The artist changed their name to American Artist in the early years of their career, an avatar intended to allow Artist to move through online space with a degree of anonymity. Simultaneously, Artist's name change pushes back at the quiet yet ever-aggressive bias of search engine optimization (SEO), Google's "roving eye" that by surfacing and prioritizing only certain results, establishes a hierarchized social narrative, history, and visual culture. Now anyone searching "American artist" on the Internet, receives American Artist as the first hit, right alongside, for example, Google's suggested selection of qualified "Artists / United States" such as Andy Warhol, Jean-Michel Basquiat, Edward Hopper, Jackson Pollock, and Jasper Johns. In this way, Artist gently subverts and challenges a canon, with the presence of their name in the company of a mastery recognized by art history, standing

as a durational performance that is virally, algorithmically enacted through their avatar, without the artist's physical self ever even being present.

The work of the avatar positions Artist's engagement of what they name as "Black radicalism and organized labor [in] a context of networked virtual life" [5] at a unique intersection, a crossroads encountered by those looking for Artist, and, too, by those who are not but may stumble across Artist's work accidentally in searching. With the search term "American artist" having innumerable results following the first hit of Artist's own website, the artist's legal name has no trace, rendering Artist in a sort of spatial limbo, a viral every-where and no-where that, in breaking with the standards of hypervisibility of pop blackness on the Internet. This action stands in the break and shows us how we might ourselves break broken systems via the creative re-application of these systems' own material toward the purpose of a strategic disruption and refusal.

Yes! Why not break the thing that's broken? Why not corrupt the corrupted? The foundation we build on is faulty. Course correcting, we will rise in our errata. We resist being subsumed; we keep sight of the beyond, those rapturous wormholes where rupture can get rolling. The beyond is blurred, it is runny. Our blur is a dance floor at 4AM, that moment where in the crush of all-bodies lit up

under strobes like firecrackers, we become no-body, and in the gorgeous crush of no-body, *we become every-body*. Our song is playing, now let us build a gooey world to go along with it.

The glitch is a tool: it is socio-cultural malware. Bodies traveling through the glitch fail joyfully, as currents along wires that vein social machinery, prompting freeze, flounder, a shuddering shutdown. The glitch is disinformation, virally transmitted as a means of undermining the architecture of gender, shaking it at its core, revealing its inherent fallacy.

Gender is a carefully constructed economic performance as much as it is a socio-cultural one. Gender exists and is protected as a means of insuring bodies, bestowing value on those who labor under its coercion successfully and compliantly, ascribing to its aggressive algorithm. Encrypted anti-bodies, body errors, systemically unreadable, push the machine of gender to its limits. Now wobbly and weakened by this virus, the machine is readied for movement, for change.

We, the viral glitch, want broken ruins, a pollution as politic: punctures in the surface, a bubbling skin, all hell to break loose, destroying all that shit. The alternative is *this* world right now, *this* life—and this world is not enough. We cannot wait around to be remembered, to be humanized, to be seen. It is our responsibility collectively

to infect, and, as we prompt social seizure, to bear witness to and for one another, to make impossible pathways secure and viable as all else short-circuits toward a triggered collapse.

ALL BODIES CAN BE EVERY-BODY. We can get free! Writer Saidiya Hartman notes that "captivity ... engenders the necessity of redress, the inevitability of its failure, and the constancy of repetition yielded by this failure."[6] As we fail, we morph. As we morph, we transcend captivity, slippery to those forces that strive to restrict, restrain, and censor us. Glitch-as-virus presents us with a sharp vision of decay, a nonperformance that veers us toward a wild unknown. This is where we bloom.

It's time for new mechanics.

Let's mutate, please.

Bye, binary! Buffer forever.

10 – GLITCH MOBILIZES

And yeah, sometimes I say "bodies" when maybe I should
say "people"
but I'm scared of not being able to touch skin anymore.

—Caspar Heinemann, "Magic Work"

Facebook's fifty-eight gender options (and three pronouns, lest we forget!), first made available for users in 2014, was not a radical gesture—it was neoliberalism at its finest.[1] If a body without a name is an error, providing more names, while proffering inclusivity, does not resolve the issue of the binary body. Rather, it makes and requires a box to be ticked, a categorization to be determined. Binaries are still presented within the variety of options, and moreover recognition via these platforms urges us to believe that signifying who we are to others is the only pathway to being deemed fit to participate. Poet, artist, and "academia-adjacent independent researcher" Caspar Heinemann puts it best: "In a climate of generalized precarity and instability, naming skin should be the least of our worries; if everything is collapsing, gender's coming down with it. So traumatized cyborg subject is the new normal, but is that the best we can hope for?"[2]

Perhaps the personage of the "cyborg subject" is in and of itself the problem. Artist Devin Kenny reminds us: "We have to keep in mind that this is a recreation through mediation, often one that can be traced back to one Internet Protocol address, and therefore one personage."[3] If we cannot shed Internet Protocol (IP) address tracking without the aid of a virtual private network (VPN) or some proxy like it, what other alternatives are there to protect our digital biometrics as we aim to imagine, to mobilize, to collectivize?

Writer and computer programmer Alexander Galloway, in his 2012 book *The Interface Effect*, argues toward what he calls "generic difference" and how the rejection of "the assignation of traits" might carry biopolitical potential, nudging us one step closer to living beyond the trauma and trouble of gender as one such assignation:

> The trick . . . is thus . . . to abstain from the system of biopolitical predication, to abstain from the bagging and tagging of bodies . . . This does not mean that all bodies are now blank. Quite the opposite. All bodies are full. But their fullness is a generic fullness, a fullness of whatsoever they are. Likewise, it does not mean that difference has "gone away." The opposite is the case, as difference may now finally come into its own as generic difference.[4]

Galloway's "generic difference" theory proposes a path to a body that is inherently fluid, a body emancipated from ever being asked to register its traces online. As such, this kind of body renders itself useless as a subject of capital's regime of mining and profiting from data. Generic difference keeps all doors open, all boxes— ticked, unticked, and those yet to be imagined beyond our wildest dreams of revolution—a possibility. Thus, in the face of pressure to constantly classify oneself, identifying ways to mobilize through (and despite) these digital territories is important. The anxious question remains: is the sacrifice of true autonomy, the distribution of these bodily traces, worth it if it means we can be part of something greater than ourselves? Especially if that is something that helps us shape ourselves and, by this shaping, reshapes the world?

Time has passed. Despite the loss of innocence that has come with the shift in understanding of how our digital traces might be manipulated, capitalized on, and deployed, the increased presence of intersectional bodies that transcend the bureaucratic violence of a single-box tick remains a key component of why the Internet still matters. Though far from its initial promise of utopia, the Internet still provides opportunity for queer propositions for new modalities of being and newly proposed worlds.

Sociologist Sherry Turkle's 2011 book *Alone Together* argues that through our increased use of technology we remain connected but increasingly isolated from one another.[5] This turn of phrase is frequently weaponized to undermine the value of the digital and speaks recklessly through a white, straight, cisgender lens. Turkle's fear-mongering equation *Internet* = *alienation* fails to take into consideration the enduring relevance of this material most specifically for queer people, female-identifying people, and people of color. To reify the binary of, on the one hand, the Internet as a dead utopia and, on the other, "real life" (read: IRL) as being devoid of actual and/or social death for QTPOCIA+ bodies is a violent propaganda. The Internet remains a club space for collective congregation of marginalized voices and bodies when all else fails. In fact and in concept "real life" as it travels in an unbroken loop between on- and offline is sexist, racist, classist, homophobic, transphobic, and ableist. As glitch feminists looking to build new communities and new worlds, we have to ask, *Can our "digital real" please live?*

The Internet continues to be a place of immense intimacy, where an "opening up" of being can occur, and where one can dare to be vulnerable. The Internet's virtual channels provide protection from physical injury, make room for an expression of ideas and politics in a

fantastic forum, thus amplifying collectivity, coalition-building, and one's courage to individuate. Artist Hamishi Farah reflects on his first experiences on the Internet noting, "I was pretty isolated growing up . . . Being welcomed and appreciated in a community online [was] the first time I really felt part of something . . . That's the first experience of the Internet: that moment it stops being 'the Internet' and just becomes another thing/part of living."[6]

Writer Shaadi Devereaux further unpacks these tensions and calls for a mobilized, activated collectivity in her 2014 essay "Why These Tweets Are Called My Back." Here, Devereaux (re)claims for herself and those in her online community the platitude of "Toxic Twitter," taking it for the communal name of a group "largely made up of Afro-indigenous, Black, and NDN women" in which they can talk about their lives. "It's no mistake that established media demean what is in many cases the one platform to which marginalized women have access. You've been told to watch us but not engage: the very definition of surveillance," she writes.[7]

Devereaux goes on to explain why social media still matters to her, citing "digital feminism [as] a space where [one] can engage with other black women overlooked in the academy, spread their work, and offer . . . analysis on black artforms." As Devereaux tells it, what began for her

and many others as "yelling into the void" transformed into a call-and-response in which "other women began to answer":

> Social media has lifted the barrier between consumers of media and media itself, transforming that relationship into one of active engagement. It has also lifted the barrier between women like us—displaced, disabled, trans, indigenous, and black—and the parts of society that were never supposed to deal with us . . . Suddenly a black trans woman denied access to any space you might enter is right here talking back to you with nuanced media critiques. A journalist can put up an article and within seconds readers are challenging the ethics of the reporting and the framing of subjects who can no longer be rendered passive.[8]

Devereaux's project of "Toxic Twitter" collectivity establishes important groundwork as we seek out other examples of how we mobilize via digital platforms and networked communities. Queer club and nightlight collectives such as Papi Juice (@papijuicebk, New York), GUSH (@gushofficial, New York), Pxssy Palace (@pxssy palace, London), and BBZ LONDON (@bbz_london, London) amongst others have risen out of a generation searching to situate in physical space an AFK response to

faces, voices, and visions that often call out in affirmation to one another online. Images from these events and the communities that they celebrate are then shared via Instagram, providing a living archive of a living history. Thus, the explorations that might begin at night on the Internet traverse the online-to-AFK loop.

The UK-based art criticism duo and self-described "art critic baby gods" *The White Pube* is comprised of collaborators Gabrielle de la Puente and Zarina Muhammad. Per their Instagram and Twitter @thewhitepube, the two are "unprofessional, irresponsible part-time critics" who "write about exhibitions n the way the art world operates." Having met in 2015 on a fine arts BA course at Central St. Martins art school at the University of London, *The White Pube* arose out of a feeling of alienation to, and engagement with, the art world. As part of its politic, they commit wholly to emoting through digital affect. Rich in emojis and short-form tweet-speak, *The White Pube* reflects on and reviews the art/world with a directness, intimacy, and honesty that lends a confessional texture to their writing. Their approach has been dubbed "embodied criticism," in recognition of the intensity of emotion as a strength in speaking about art and visual culture. The artists see exhibitions AFK then bring them to a growing global audience online, providing sharply instinctual insights and lyrical commentary.

In a review written in 2018, Muhammad exclaims: "I wana talk about the BASIC, VIOLENT issue of white artists using black bodies as literal props."[9] Amid ongoing discussions on "the dominance of the white male critic," *The White Pube* empowers criticism that problematizes and interrogates triggers and fault lines across art history and visual culture.[10] In doing so, the duo demands and builds a more transparent and direct mode of dialogue, a forum that works against the tired establishment of a white/male art world and the highly flawed narratives it espouses.

Making space for critique, feedback, and a heightening of self-awareness works peer to peer both on- and offline, but also exists intergenerationally. Brooklyn-based POWRPLNT (@powrplnt) is "committed to providing digital arts education and access for all . . . provid[ing] the resources, mentorship, and education to thrive in the creative economy today."[11] Looking to "elevate digital literacy and encourage expression via technology," the group was founded in 2014 by artist and community organizer Angelina Dreem and creative entrepreneur Anibal Luque, and later joined by artist and researcher Salome Asega. POWRPLNT's tagline of "Technology is a right, not a privilege" underscores the issue of access to technology as a primary contributor to "the digital divide" across generations, geographies, and

communities. By creating a space to gather, learn about technology, and re-distribute knowledge democratically, POWRPLNT mobilizes across generations, providing the tools to drive strategic dismantlements.

The glitch mobilizes. This is our task: to keep mobilizing, modifying, shapeshifting with pride. This slip and slide is transcendent. We are everything and nothing, everywhere and nowhere, always in motion. To quote BUFU (@bufu_byusforus), a New York-based collective of "queer, femme and non-binary Black and East-Asian artists and organizers": "Where else were We to go? / Who else believed in our potential but Us?"[12] In mobilizing, we find others like us, and, in so doing, we find ourselves. In mobilizing, we remain fugitive: we stand on the outside, not to look in, but, stateless, to occupy and grow with intention. This mobility is gorgeous, slippery, keyed up, catastrophic. It is the thing that keeps us blurry and unbound, pushing back against hegemony.

11 – GLITCH IS REMIX

What I mean is, what can we do with our bodies? . . .
I want to move my body back and forth, back and forth.

—T. Fleischmann, *Time Is the Thing a Body Moves Through*

Queer people, people of color, and female-identifying people have an enduring and historical relationship to the notion of "remix." To remix is to rearrange, to add to, an original recording. The spirit of remixing is about finding ways to innovate with what's been given, creating something new from something already there.

We are faced with the reality that we will never be given the keys to a utopia architected by hegemony. Instead, we have been tasked with building the world(s) we want to live in, a most difficult yet most urgent blueprint to realize. If we see culture, society, and, by extension, gender as material to remix, we can acknowledge these things as "original recordings" that were not created to liberate us. Still, they are materials that can be reclaimed, rearranged, repurposed, and rebirthed toward an emancipatory enterprise, creating new "records" through radical action. Remixing is an act of self-determination; it is a technology of survival.

This world is not built for us; yet still, somehow, we are here, standing against all odds. Similarly, the Internet, an electrifying black mirror, was not built as a material for our bodies. At its worst, it only reflects back to us the misery of the world around us. Still, we create opportunity for fugitivity in our deployment of digital material. Online, we magnify our avatars, our vast and varied selves. Through this performative practice we resist an exclusionary canon of visual culture that, unable to decipher our coding, seeks to erase us entirely. Glitch carries a technology of remix within its code. We experiment via digital material as a means of pushing boundaries within the AFK world, remixing via a complex choreography as we build new corpo-realities. Despite the supremacy of the original recording, still, we rise.[1]

But still, it can be difficult to find our footing.

Artist Tabita Rezaire grapples with this challenge in her creative and spiritual practice, applying art as a "healing technology" in an effort to reconcile with a (digital) world that is far from the paradise promised at the birth of the Internet. In her video work *Afro Cyber Resistance* (2014), Rezaire problematizes the reality of an Internet driven by the West, one that filters and excludes the contributions of Black people within its historical arc—what she describes as "electronic colonialism." Rezaire observes:

Black people have been protesting and imagining different ways—their own ways—of existing on the Internet. If we must still use the Internet, how can we use it in a way that is uplifting and inspiring for the communities affected by the Internet's racism. *Afro Cyber Resistance* is a pamphlet and a call for the decolonisation of the Internet.[2]

Glitch, in its remix, embodies what Rezaire gestures toward, identifying ways to make use of the Internet toward the goal of "uplifting . . . communities" as an application of digital material to grapple with the complicated and oft-contradictory nature of the material itself. Decolonizing through occupation of a challenging digital landscape, the acts of seizure and reclamation are two pillars of the glitch political agenda. As glitch feminists, we aim to "alter . . . computer memory" through our exploration of new modes of existing, surviving, and living, both AFK and on the Internet.[3]

To alter machinic memory, designer and researcher Simone C. Niquille explores new forms of the body in her research of what she calls "avatar design and identity strategy." Niquille approaches the body as a design challenge, considering ways of restructuring physical forms toward the goal of remixing identity altogether. "The contemporary accelerating frenzy of collecting as much

data as possible on one single individual to . . . construct a 'fleshed out' profile is a fragile endeavor," Niquille explains. "More information does not necessarily lead to a more defined image."[4] Glitch feminism agrees: the possibility of failure against achieving a "more defined image" has wonderful and weird prospects. For Niquille, the collection of data alone is not the ultimate threat, not if one can subvert it by designing bodies that, in working against the design of the world around them—one biased by a particular notion of a "normal" body, one that is gendered, racialized—remain illegible to the machine.

For Niquille's short film "The Fragility of Life" (2016), she brings to life a character named Kritios They. Kritios They was produced by Niquille using a program called Fuse, now part of Adobe Creative Cloud suite, designed to create 3D models and animated characters. Fuse presents the user with body segments to be assembled into new forms; to do this the program itself is set up with a series of embedded assumptions about what a body should look like, how pieces of it should fit together, and what makes a body whole or even human. When the program is pushed to its limits, the rendering of these forms fails to recognize certain corpo-realities, establishing that bodies that do not blend seamlessly cannot qualify as a body at all. Niquille unpacks this:

A lot of these processes and workflows demand
content that is very specific to their definition of the
human form in order to function. As a result, they
don't account for anything that diverges from that
norm, establishing a parametric truth that is biased
and discriminatory. This raises the question of what
that norm is and how, by whom and for whom it has
been defined.[5]

The implications of this are significant if we view them
through the lens of surveillance and image-capturing
digital technologies. What is and is not read as a body
opens up a myriad of possibilities, some that allow for
greater refusal within hierarchies of visibility and others
that flag a body that cannot be read as a threat worth
targeting, heightening the vulnerability of that body as it
moves through space.

Still, "the body conceived of as a machinic assemblage
becomes a body that is multiple," meaning that as it
"contains multitudes" (to harken back to where we began
with Walt Whitman and E. Jane) a body that is gooey,
blurry, full of seams, or simply glitched is one that both
absorbs and refracts, becoming every-body and no-body
simultaneously.[6]

Niquille points to the forensic animations created by
the defense for the trial of George Zimmerman in the

murder of the Black teenager Trayvon Martin in 2012. These digital reenactments, based on data collected at the scene, were staged using an actor equipped with sixteen sensors, moving as the defense theorized Zimmerman may have moved in exiting his car and pursuing Martin down the street the night of the shooting. Niquille explains:

> [In] a roughly two-hour long video of Zimmerman's attorney questioning the animator on his process . . . [the] animator states that he was the one wearing the motion capture suit portraying both Zimmerman as well as Martin. If this weren't already enough to debunk an objectivity claim, the attorney asks: "How does the computer know that it is recording a body?" Upon which the animator responds: "You place the 16 sensors on the body and then on screen you see the body move in accordance."[7]

The use of sixteen sensors to "read" the moving form in the production of a forensic animation serves to demonstrate the flaws of legibility and the bias presented therein, especially in this case where there was no singular witness to Martin's shooting. The legibility of Zimmerman's body and Martin's body are both scripted from a particular body of evidence, data dictating theorized movements

culled from "coroner photographs, police reports, the coroner's report, witness depositions and photos taken by responding police officers."[8] The judge on the case ruled that the defense could not enter the animations as evidence.[9] Still, the machinic bias enacted by the panopticon of the mapping of the body through digital technologies is filled with hopeful holes, leaving us to ask: If a body is not legible as a body, and therefore cannot be read, will it be "seen"? Can it ghost, skirting the omnipresent digital eye? Failing recognition, can it successfully cease to exist?

Artist Zach Blas's *Facial Weaponization Suite* series (2011–14) pushes us further in our quest toward strategic illegibility. This work stands as nothing more than a glitch-resist within an ever-burgeoning culture of surveillance capitalism. The project builds what the artist calls "collective masks" modeled from the aggregation of facial data gleaned from group workshops. The results are "amorphous masks that cannot be detected as human faces by biometric facial recognition technologies."[10] The artist then uses these masks to perform and stage public interventions.

Blas creates different types of masks in the interest of interrogating different types of biometric data collection. For one mask, "Fag Face Mask," the artist culls biometric facial data based on a grouping of queer men, pushing back

against technologies that profile sexual orientation based on algorithmically culled traits. For another mask, the artist investigates the construct of blackness across three channels: "the inability of biometric technologies to detect dark skin as racist, the favoring of black in militant aesthetics, and black as that which informatically obfuscates."[11] Thus Blas rejects singularity and embraces collective action. It brings to the forefront the tension between the luxury and privilege of being able to choose to refuse visibility, and, conversely, the tool of this refusal. This in turn becomes a key strategy that provides the possibility of greater mobility for vulnerable bodies who need it.

We can see another form of remix and a different approach to masking-as-resistance in American Artist's project *A Refusal* (2015–16).[12] For this durational work, the artist for one full year replaced all would-be image content posted on their social media with blue rectangles and redacted any text with black bars. In order to gain access to the content, followers had to request an in-person meeting with the artist. By refusing to input their behavioral data, Artist challenged the construct of a virtual self while simultaneously withdrawing their labor as a producer of content on networked platforms. This action rendered Artist useless to the logics of the digital economy. Meanwhile, it increased the value of the content that remained on Artist's social media platforms as a

result of its rarity, a gatekept material whose circulation is controlled by the individual themselves. In limiting the supply of the "product," the artist created a shortage thereby amplifying the demand for the raw commodity: access to the physical presence of the person.

Florence Okoye, in her discussion of the unseen, gestures to new possibilities in making room for glitched bodies through the strategic redesign and critical engagement of user experience. Okoye puts it simply: "The bot provides testament to the unseeing of its creators." She asks, "How can one envision the needs of the other when one doesn't even realize the other exists? . . . Hasn't the glitch then become a means of seeing the unseen?"[13]

In the face of surveillance capitalism, the perhaps improved anonymity of data, advanced modes of encryption, or advocacy for better data control or ownership by individuals themselves is actually not the right battle to be fighting. To revolutionize technologies toward an application that truly celebrates glitched bodies, perhaps the only course of action is to remix from within, specifically programming with the unseen or illegible in mind as a form of activism. To "advocate for the user," in Okoye's words, one must innovate, encode, engineer the error *into the machine*, as a remix rendering the machine unrecognizable to itself, prompting its failure as a radical act.

12 – GLITCH SURVIVES

One is not born, but rather becomes, a body. And one is not born, but rather becomes, a glitch. The *glitch-becoming* is a process, a consensual diaspora toward multiplicity that arms us as tools, carries us as devices, sustains us as technology, while urging us to persist, survive, stay alive.

Glitch Refuses

We are building a future where we can have the broad range we deserve. We refuse to shrink ourselves, refuse to fit. Fluid, insistent, we refuse to stand still: we slip, we slide. We recognize the contributions of blackness toward liberatory queerness, and the contributions of queerness toward liberatory blackness. We fail to function for a machine that was not built for us. We refuse the rhetoric of "inclusion" and will not wait for this world to love us, to understand us, to make space for us. We will take up space, and break this world, making new ones.

Glitch Is Cosmic

We recognize that bodies are not fixed points, they are not destinations. Bodies are journeys. Bodies move. Bodies are abstract. We recognize that we begin in *abstraction* and then journey toward *becoming*. To transcend the limits of the body we need to let go of what a body should look like, what it should do, how it should live. We recognize that, within this process of letting go, we may mourn; this mourning is a part of our growing. We celebrate the courage it takes to change form, the joy and pain that can come with exploring different selves, and the power that comes from finding new selves.

Glitch Throws Shade

We throw shade by existing in the world, by showing up and not only surviving, but truly, fully, living. We practice the future in the now, testing out alternatives of being. We openly, honestly consider together how to be strategically visible, when visibility is radically necessary.

Glitch Ghosts

We ghost on the body, refusing to respond to its cultural texts, incessant calls, damaging DMs. We acknowledge that gender is an economy. It is a spoke in the wheel of capitalism. We reject being bought and sold. We feel no

guilt or shame about turning our backs on a market that wants to eat us alive. We will strategize and collectivize toward uselessness, a failure that imagines, innovates, emancipates.

Glitch Is Error

We are the most fantastic and beautiful mistake. Never meant to survive, we are still here: an error in the algorithm. We are not empty signifiers, however; we are not dead-end hyperlinks. We reject the violent act of naming. We will reconfigure ourselves as we see fit. Modifying and recoding, we choose our own names, build our own families and communities, proudly fail in the present as we dream new futures.

Glitch Encrypts

We are encrypted: how we are coded is not meant to be easily read. We recognize that the *care-full* reading of others is an exercise of trust, intimacy, belonging, homecoming. We reject the conflation of legibility and humanity. Our unreadable bodies are a necessary disruption. Our unreadable bodies can render us invisible and hypervisible at the same time. As a response to this, we work together to create secure passageways both on- and offline to travel, conspire, collaborate.

Glitch Is Anti-Body

If to be recognized as a body that deserves to live we must perform a certain self—look a certain way, live a certain way, care for one another in a certain way—we strike against the body altogether. We will hold mirrors up for one another, hold and care for the reflections seen. We will see one another and the selves we become, recognizing those selves as real, loved, and so very alive.

Glitch Is Skin

While both protective and permeable, the skin of the digital, despite its entanglements, remains necessary as a tool of experimentation. Thus, we celebrate ourselves and the framework offered by the skins we put on and take off. We recognize that our performance of other bodies is prosthetic. We recognize that the skin of the digital transforms and is transformative.

Glitch Is Virus

We want to corrupt data. We want to fuck up the machine. Infectious, viral, we will tear it all down. We recognize that in this breaking, there is a beginning.

Glitch Mobilizes

We will mobilize and take action! We recognize that all work cannot be done all the time all on the Internet.

Completing the online-to-AFK loop, we will dare to live away from our screens, embodying our ever-slipping selves as an activist action. Empowered by the virtual worlds we traverse, we will reboot and rebuild these worlds when they no longer suit and need to shift. Along this loop, we commit to making space for rigorous criticism, feedback, play, and pleasure as activism.

Glitch Is Remix

Affirming our role in building new worlds, we will imagine, innovate, and remix. We will rearrange and repurpose by any means necessary, rendering what rises from this rebirth unrecognizable from the violence of its original. We will create fissures in the social and cultural algorithm as an active act of advocacy, advocating for the user, advocating for ourselves and advocating for one another.

Glitch Survives

In 1993, one year before Sadie Plant coined the term *cyberfeminism*, poet Lucille Clifton wrote "won't you celebrate with me." As glitch feminists we call for it here, celebrating with Clifton at her request and sharing her transformative words:

> won't you celebrate with me
> what i have shaped into

> a kind of life? i had no model.
> born in babylon
> both nonwhite and woman
> what did i see to be except myself?
> i made it up
> here on this bridge between
> starshine and clay,
> my one hand holding tight
> my other hand; come celebrate
> with me that everyday
> something has tried to kill me
> and has failed.

Clifton's "i made it up," gestures to both playground and battlefield. Building a future and a future self at the same time is no easy task. These words seem a response to Essex Hemphill's 1995 wondering, wandering on cyber-space: "Can invisible men see their own reflections?" Glitch feminism travels the passageways between the starshine of the digital and the clay of AFK. It is modeled on no model and asks for a better world. Like Clifton, we hold our own hands and the hands of one another in an act of solidarity, with little else to lean on. *What do we see to be except ourselves?*

The open-ended question of the body is one of the greatest of our time. Our embodiment of glitch is thus an

expression of spatial desire, a curious inquiry in service of remapping the physical form and how we perform and (re)structure it. Gender as a construct is a falsehood. As glitch feminists, we challenge the collective discourse that designates the gender binary as a natural progression. Binary gender keeps us from our cosmic corporeality, that space where the body can expand and explore in the freedom of abstraction. Nope, this cannot continue. The glitch pushes the machine to its breaking point by refusing to function for it, refusing to uphold its fiction.

What does it mean to find life—and to find ourselves—through the framework of failure? To build models that stand with strength on their own, not to be held up against those that have failed us, as reactionary tools of resistance? Here is the opportunity to build new worlds. As citizens transmogrified by the material of the digital, we recognize that limitlessness is possible, that we can expand in every direction. I found new landscapes through being borne and carried online, those early days where I flexed as a digital Orlando, shapeshifting, time-traveling, genderfucking as I saw fit. I became myself, I found my body, through becoming, embodying, a glitch.

Each among us containing multitudes, as glitch feminists we are not one but many bodies. All these Internet avatars have taught us something: that reality is what we

make of it, and in order to make a "real life" whether online or AFK, we must seize it. This is our right. United, we will no longer ache for visibility or recognition or equality. This relinquishing of power as reparation for harms done will never happen voluntarily, or meet our terms—so why waste ourselves in waiting for it? By breaking it all, we pave the way for the kaleidoscopic future that we want.

What glitch feminism is proposing instead is this: *We will embody the ecstatic and catastrophic error.* If this is a spatial battle, let us become anarchitecture.

We will be not "single beings" but be every single being and every single avatar, expanding to a rageful full range that makes this gendered engine screech to a halt.

We will let our liquidity roar with the deep decibels of waves. We will cruise as wild, amorous, monstrous malfunctions.

We will find life, joy, and longevity in breaking what needs to be broken. We will be persistent in our failure to perform in pursuit of a future that does not want us, enduring in our refusal to protect the idea, the institution of "body" that alienates us.

Here is where new possibilities gestate.

As glitch feminists, we will search in the darkness for the gates, seek the ways to bring them down and kill their keepers.

So, go ahead—tear it all open. Let's be beatific in our leaky and limitless contagion. Usurp the body. Become your avatar. Be the glitch.

Let the whole goddamn thing short-circuit.

included in publications and productions put forward by the *F Word* (UK), Kingston University (UK), the Photographers' Gallery (UK), Stockholm University (SW), University of Massachusetts Amherst (US), Boston University (US), McGill University (Canada), and beyond.

I have been fortunate to journey with glitch feminism internationally, participating in forums such as "Theorizing the Web" held at the International Center of Photography (2015, US); "Technofeminism Now," "Technology Now: Blackness on the Internet," and then "Post-Cyber Feminist International" all held at the Institute of Contemporary Arts London (2015, 2016, 2017, UK); the Wonder Woman Festival at Castlefield Gallery (2017, UK); Arcadia University (2017, UK); the Forum for Philosophy at the London School of Economics (2017, UK); "Decolonizing Bots" at Het Nieuwe Instituut (2017, NL); Impakt Festival (2017, NL); Transmission Gallery and the Centre for Contemporary Arts Glasgow (2018, UK); School of Visual Arts (2018, US); "<Interrupted = Cyfem and Queer>" symposium (2018, DE); Mapping Festival (2018, CH); "Re/Dissolution: Learning from Pixels" symposium at the Academy of Fine Arts Munich (2018, DE); Rewire Festival 2018 (2018, NL); Eyebeam's "Refiguring the Future" conference (2019, US), and more. This is proof that glitch feminism is living material and part of an urgent conversation,

ongoing. I am eternally grateful to those bbz who organized the panels and events at which I presented glitch feminism and for all those who took the time to attend and critically engage with a work-in-progress.

All this is to say that what lies within the pages of this book began with outrage, desire, concern, joy. It surged from some of my own darkest moments as a queer body in motion, and lit the way, allowing me to advance with courage. It is part of an exigent global dialogue.

Outside of *The Society Pages* and *Rhizome*, an earlier excerpted form of this text meditating on some of the ideas shared here was published in 2018 in an independent compilation titled *Alembic*, put forward by the gallery and workspace Res. in Deptford, South East London.

Glitch Feminism as a manuscript grew and found its footing in conversations with beloved folx Elizabeth Koke (who literally guided it from the dancefloor of Nowhere Bar, out into the daylight) and Angelica Sgouros (also on the dancefloor at Nowhere Bar), who carried this work far beyond with strength, vision, courage. Early research as I began this book came from two super rad research assistants: the inspiring poet, artist, star-child Caspar Heinemann, and the equally inspiring writer and editor Laura Bullard. The structure of and material for my glitch feminist lectures starting in 2017 were composed with care by Anna Carey, who brought the visuality of

glitch feminism to new heights with her keen eye for design and savvy Keynote slay.

In performance lecture form from the dot and now here, too, *Glitch Feminism* celebrates the important creative contributions and very necessary work of E. Jane (and their Mhysa), manuel arturo abreu, and Shawné Michaelain Holloway. Honor them with me.

Other folx who encouraged, celebrated, challenged, and galvanized this work, listed alphabetically: Alexandra Bynoe-Kasden, Andrew Cappetta, Brittni Chicuata, Nora Clancy, Bibi Deitz, Rosalie Doubal, Thelma Golden, my brilliant and very woke editor Leo Hollis, Madeleine Hunt-Ehrlich, Lena Imamura, Andreas Laszlo Konrath, Moira Kerrigan, Taylor LeMelle, Kamala Mottl (*aloha wau iā 'oe*, "Geeve um!"), Kaitlin Kylie Pomerantz, Angola Russell, Ernest Russell (DIGITALMAN), Hannah Sullivan, Sarah Shin, Mark Tribe, McKenzie Wark, Zadie Xa. I am in eternal debt and gratitude for the Carl and Marilynn Thoma Art Foundation and the Robert Rauschenberg Residency for the support they have provided me in the creation of this manuscript. There have also been so many amazing folx who took the time to be vulnerable, passionate, wild, wonderful, and who wrote me with their own personal stories, thoughts, and positive vibes over the course of my writing: To each of you, your words arrived just in time, gave me insight,

brought me back from the edge, and carried me forward with confidence and self-determination in my heart.

Finally, to all the artists, writers, thinkers, and gender-hackers included in these pages: I am deeply grateful for the work you put forward into the world, the multitudinous selves you bravely share online and AFK, and the eternal solidarity you show as we continue to co-conspire in breaking the binary code.

Cyberfam: In all your brilliance and allyship, I thank you for your vision, your refusal, and, above all, your love. You are everything.

USURP THE BODY! BECOME YOUR AVATAR!

Image Credits

DIGITALMAN and Legacy Russell, "Black Baldessari (Emoji Portraits)," series of composites completed 2018, courtesy of the artists.

Mark Aguhar, "These are the axes," 2012, courtesy of the estate of Mark Aguhar.

E. Jane, "Nope (A Manifesto)," 2016, courtesy of the artist and Codette.

boychild, "Moved by the Motion" with Wu Tsang, 2014, courtesy of the artist.

Juliana Huxtable, "Untitled (Psychosocial Stuntin')," 2015, color inkjet print, 40 × 30 inches, courtesy of the artist and JTT, New York.

Victoria Sin, Performance at "Glitch @ Night" organized by Legacy Russell as part of *Post-Cyber Feminist International*, 2017, ICA London, courtesy of ICA London, photograph by Mark Blower.

Rindon Johnson, "My Daughter, Aaliyah (Norf, Norf)," 2016, courtesy of the artist.

manuel arturo abreu, 2014 tweet, courtesy of the artist.

Excerpted Text

Etheridge Knight, "Feeling Fucked Up," *The Essential Etheridge Knight*, University of Pittsburgh Press, 1986, p. 34.

Anaïs Duplan, "On a Scale of 1–10, How 'Loving' Do You Feel?" *Take This Stallion: Poems*, Brooklyn Arts Press, 2016, p. 12.

Richard Siken, "Seaside Improvisation," *Crush*, Yale University Press, 2005, p. 8.

Yusef Komunyakaa, "Fever," *Neon Vernacular: New and Selected Poems*, Wesleyan University Press, 1993, p. 24.

manuel arturo abreu, "A PIECE OF WRITING THAT WON ME $200 IN EIGHTH GRADE," *List of Consonants*, Bottlecap Press, 2015, p. 53.

Ocean Vuong, "Threshold," *NIGHT SKY WITH EXIT WOUNDS*, Copper Canyon Press, 2016, p. 3.

Billy-Ray Belcourt, "The Cree Word for a Body Like Mine is Weesageechak," *This Wound Is a World: Poems*. Frontenac House Poetry, 2017, p. 9.

Caspar Heinemann, "Magic Work: Queerness as Remystification," 2014, available at docs.google.com/document/d/1

-d1RpWJ2nR4iN2BKEwfHdQFgdPqKW-a8q7O1ZAiN-ltU.

T. Fleischmann, *Time Is the Thing a Body Moves Through*, Coffee House Press, 2019, pp. 9, 54.

Lucille Clifton, "won't you celebrate with me?" *The Collected Poems of Lucille Clifton 1965–2010*, edited by Kevin Young and Michael S. Glaser, BOA Editions, 2012, p. 427.

Notes

00 *Introduction*

1. In this text I will celebrate the use of capital B for "Black". "Blackness" will maintain lower case b in the interest of making space for the ontological framework that blackness proposes across a cultural, social, political discourse.

2. James C. Scott, *Seeing Like a State: How Certain Schemes to Improve the Human Condition Have Failed*, New Haven, CT: Yale University Press, 1999, p.183.

01 *Glitch Refuses*

1. "An Interview with E. Jane," *AQNB*, February 16, 2016, aqnb.com; "About," NewHive, newhive.com:80/newhive/about; "NewHive," wikipedia, en.wikipedia.org.

2. Hanna Girma, "Artist Profile: E. Jane," *Rhizome*, May 23, 2017, rhizome.org.

3. "An Interview with E. Jane," *AQNB*, February 16, 2016, aqnb.com

4. José Esteban Muñoz, *Cruising Utopia: The Then and There of Queer Futurity*, New York: NYU Press, 2009, p.1.

5. Ibid., p. 182.

6. Lisa Respers France, "Rihanna Criticizes Snapchat for Ad Referencing Domestic Violence," CNN, March 16, 2018, cnn.com.

7. Amanda Arnold, "Snapchat's Offensive Rihanna Ad Cost the App $800 Million," *The Cut*, March 17, 2018, thecut.com.

8. Thinking here of Nikki Giovanni's "Seduction / Kidnap Poem" (1975).

9. Jean-Luc Nancy, "Fifty-Eight Indices on the Body," in Jean-Luc Nancy, *Corpus*, translated by Richard Rand, New York: Fordham University Press, 2008.

10. Alex Hern, "Google's Solution to Accidental Algorithmic Racism: Ban Gorillas," *Guardian*, January 12, 2018, theguardian.com.

11. Ayana Lage, "Google's 'Arts & Culture' App Is Being Called Racist, But The Problem Goes Beyond The Actual App," *Bustle*, January 18, 2018, bustle.com.

12. Essex Hemphill, "On the Shores of Cyberspace," lecture given at "Black Nations/Queer Nations?" conference, City University of New York, 1995.

13. Judith Butler, *Excitable Speech: A Politics of the Performative*, New York: Routledge, 1997, p. 5.

14. Kate Bornstein in Conversation with Zackary Drucker,

"Gender Is a Playground," *Aperture* 229, Winter 2017, p. 29.

15. Emily Siner, "What's A 'Glitch,' Anyway?: A Brief Linguistic History," NPR, October 24, 2013, npr.org.

16. Ibid.

17. bell hooks, *Feminism Is for Everybody: Passionate Politics*, Boston: South End Press, 2000.

18. Donna J. Haraway, *The Haraway Reader*, New York: Routledge, 2004, p. 38.

19. Cornelia Sollfrank, "The Truth about Cyberfeminism," available at obn.org/reading_room/writings/html/truth.html.

02 *Glitch Is Cosmic*

1. Virginia Woolf, *A Room of One's Own*, New York: Harcourt, Brace and Company, 1929.

2. Gene McHugh, "The Context of the Digital: A Brief Inquiry into Online Relationships," in *You Are Here: Art After the Internet*, edited by Omar Kholeif, Manchester, UK: Cornerhouse Publications, 2017, p. 31.

3. James Bridle, "#Sxaesthetic," blog entry, *Book Two*, March 15, 2012, booktwo.org.

4. Hili Perlson, "Truth in Gender: Wu Tsang and boychild on the Question of Queerness," *SLEEK*, October 29, 2014, sleek-mag.com.

5. Eric Sasson, "Is Gentrification Killing the Gay Bar?" *GOOD*, August 2, 2019, good.is.

6. Rachel Small, "boychild," *Interview Magazine*, December 10, 2014, interviewmagazine.com.

7. Manthia Diawara, "Conversation with Édouard Glissant aboard the Queen Mary II," August 2009, available at liverpool.ac.uk/media/livacuk/csis-2/blackatlantic/research/Diawara_text_defined.pdf.

8. Lisa Nakamura, *Cybertypes: Race, Ethnicity, and Identity on the Internet*, New York: Routledge, 2002, 8.

9. Initials used to preserve anonymity.

03 *Glitch Throws Shade*

1. Antwaun Sargent, "Artist Juliana Huxtable's Bold, Defiant Vision," *Vice*, March 25, 2015, vice.com.

2. Ibid.

3. "Introducing: Lorraine O'Grady and Juliana Huxtable, Part 1," Museum of Contemporary Art, Spring 2019, moca.org.

4. To resituate a term coined by curator and writer Taylor LeMelle in the context of "Technology Now: Blackness on the Internet," a program organized by Legacy Russell which took place at the Institute of Contemporary Arts and featured Rizvana Bradley, Taylor Le Melle, and Derica Sheilds. This program was presented on the occasion of the "Wandering/WILDING: Blackness on the Internet" exhibition organized by Legacy Russell at IMT Gallery, London, presented in collaboration

with the Institute of Contemporary Arts, London, 2016.

5. Petra Collins, "Petra Collins selects Juliana Huxtable," *Dazed Digital*, July 8, 2014, dazeddigital.com.

6. Jesse Daniels, "Rethinking Cyberfeminism(s): Race, Gender, and Embodiment," *Women, Science and Technology: A Reader in Feminist Science Studies*, New York: Routledge, 2001, p. 365.

7. Tina M. Campt, *Listening to Images*, Durham, NC: Duke University Press, 2017, p. 114.

8. The glitched body is a body that defies the hierarchies and strata of logic, it is proudly *nonsensical* and therefore perfectly *non-sense*. I think here of philosopher Jean-Luc Nancy's "Fifty-eight Indices on the Body," *Indice* 27, wherein he muses: "Bodies produce sense beyond sense. They're an extravagance of sense." In Jean-Luc Nancy, *Corpus*, translated by Richard Rand, New York: Fordham University Press, 2008, p. 153.

9. Florence Okoye, "Decolonising Bots: Revelation and Revolution through the Glitch," Het Nieuwe Instituut, October 27, 2017, botclub.hetnieuweinstituut.nl.

10. Maurizio Lazzarato, *Signs and Machines: Capitalism and the Production of Subjectivity*, translated by Joshua David Jordan, Los Angeles, CA: Semiotext(e), 2014, pp. 18, 26.

11. Ibid.

12. Nancy, "Fifty-eight Indices on the Body," Indice 3, *Corpus,* p.150.

13. "AF," shorthand slang for "as fuck."

14. Judith Butler and Beatriz Preciado, *Têtu* magazine interview from 2008, translated by Ursula Del Aguila for *Las Disidentes*, April 20, 2012, lasdisidentes.com.

15. Excerpted from Tony Morrison's Nobel Lecture on December 7, 1993. Toni Morrison, "Toni Morrison: Nobel Lecture," in *Nobel Lectures in Literature: 1991–1995*, edited by Sture Allén, Swedish Academy, Stockholm, Hackensack, NJ: World Scientific, 1997.

04 *Glitch Ghosts*

1. M. G. Siegler, "Eric Schmidt: Every Two Days We Create as Much Information as We Did Up to 2003," *TechCrunch*, August 5, 2010, techcrunch.com.

2. David Lyon, *Surveillance Society: Monitoring Everyday Life*, Buckingham, UK: Open University Press, 2012, p. 2.

3. "About Demographic Targeting," Google Ads Help, support. google.com/google-ads/answer/2580383.

4. David Lyon, *Surveillance Society: Monitoring Everyday Life*, Buckingham, UK: Open University Press, 2012, p. 15.

5. "Cécile B. Evans: The Virtual Is Real," *HuffPost*, August 4, 2017, huffpost.com.

6. Rindon Johnson, "What's the Point of Having a Body?" *DazedDigital*, March 6, 2019, dazeddigital.com.

7. Ibid.

8. Hortense Spillers, "To the Bone: Some Speculations on Touch, Hortense Spillers," talk given at "Hold Me Now – Feel and Touch in an Unreal World" conference organized by the Gerrit Rietveld Academie at the Stedelijk Museum, Amsterdam, NL, March 23, 2018, available at youtube. com/watch?v=AvL4wUKIfpo.

9. Rindon Johnson, "What's the Point of Having a Body?" *DazedDigital*, March 6, 2019, dazeddigital.com.

05 *Glitch Is Error*

1. Florence Okoye, "Decolonising Bots: Revelation and Revolution through the Glitch," Het Nieuwe Instituut, October 27, 2017, botclub.hetnieuweinstituut.nl.

2. manuel arturo abreu, *List of Consonants*, Bottlecap Press, 2015, p. 53.

3. "Not long ago I was in a room where someone asked the philosopher Judith Butler what made language hurtful. I could feel everyone lean forward. Our very being exposes us to the address of another, she said. We suffer from the condition of being addressable, by which she meant, I believe, there is no avoiding the word-filled sticks and stones of others. Our emotional openness, she added, is borne, in both its meanings, by our addressability. Language navigates this." Claudia Rankine, *Citizen: An American Lyric*, London: Penguin Books, 2015, p. 49.

4. micha cárdenas, "Trans of Color Poetics: Stitching Bodies, Concepts, and Algorithms," *Scholar and Feminist Online*, "Traversing Technologies" 13.3–14.1, 2016, sfonline. barnard.edu.

5. Sarah Kember and Joanna Zylinska, *Life after New Media: Mediation as a Vital Process*, Cambridge, MA: MIT University Press, 2012, pp. 88–89.

6. Ibid., p. 89.

7. micha cárdenas, "Trans of Color Poetics: Stitching Bodies, Concepts, and Algorithms," *Scholar and Feminist Online*, "Traversing Technologies" 13.3–14.1, 2016, sfonline. barnard.edu.

8. Ibid.

9. Sable Elyse Smith, "Ecstatic Resilience," New York: Recess Art, 2016, available at recessart.org/wp-content/uploads/ EsctaticResilience.pdf.

10. "The Violence of Naming and Necessity: Reading Through Porous Bodies in manuel arturo abreu's *transtrender*," *AQNB*, January 30, 2017, aqnb.com.

06 *Glitch Encrypts*

1. Tamar Clarke-Brown, "Adrift in the Chroma Key Blues: A Chat with Sondra Perry on Black Radicality and Things That Are Yet to Happen in *Typhoon coming on*," *AQNB*, May 1, 2018, aqnb.com.

2. Timothy Morton, *Hyperobjects: Philosophy and Ecology*

after the End of the World, Minneapolis, MN: University of Minnesota Press, 2014.

3. Henri Lefebvre, *The Production of Space*, translated by Donald Nicholson-Smith, Cambridge, MA: Blackwell, 1991, p. 194.

4. Jessica Pressman, "Circling Back: Electronic Literature and Material Feminism," in *Routledge Handbook of Contemporary Feminism* edited by Tasha G. Oren and Andrea L. Press, New York: Routledge, 2019, p. 237.

5. "I FEEL MOST COLORED WHEN I AM THROWN AGAINST A SHARP WHITE BACKGROUND I FEEL MOST COLORED WHEN I AM THROWN AGAINST A SHARP WHITE BACKGROUND . . ." and so on.

6. Serpentine Galleries, London, *Sondra Perry: Typhoon coming on*, 2018, serpentinegalleries.org.

7. Ibid.

07 *Glitch Is Anti-Body*

1. Jean-Luc Nancy, "Corpus" in Jean-Luc Nancy, *Corpus*, translated by Richard Rand, New York: Fordham University Press, 2008, p. 7.

2. Ibid.

3. Ibid.

4. Lynn Hershman Leeson, "Some Thoughts on the Data Body" (1994) in *Context Providers: Conditions of Meaning in Media Arts*, edited by M. Paul Lovejoy and V. C. Vesna, Chicago: University of Chicago Press, 2011.

5. Amelia Abraham, "Photographing Black, Female, HIV Positive Power," *Refinery29*, December 30, 2016, refinery29.com.

6. Hugh Ryan, "Power in the Crisis: Kia LaBeija's Radical Art as a 25-Year-Old, HIV-Positive Woman of Color," *Vice*, June 6, 2015, vice.com.

7. Amelia Abraham, "Photographing Black, Female, HIV Positive Power," *Refinery29*, December 30, 2016, refinery 29.com.

8. Alex Fialho, "Kia LaBeija," *Artforum*, January 2018, artforum.com.

9. Ibid.

10. Ibid.

11. Jasmin Hernandez, "In Conversation with Kia Labeija: Using Positivity to Trigger Awareness, Acceptance and Activism for HIV/AIDS," *Gallery Gurls*, December 21, 2015, gallerygurls.net.

08 *Glitch Is Skin*

1. Andrea Liu, "'Queer' as Refusal and Disidentificatory Act at the Yale School of Art," *Blonde Art Books*, December 20, 2017, blondeartbooks.com.

2. Gaby Cepeda, "Artist Profile: Shawné Michaelain Holloway," *Rhizome*, September 24, 2015, rhizome.org.

3. Jessica Pressler, "How an Aspiring 'It' Girl Tricked New York's Party People—and Its Banks," *The Cut*, May 29, 2018, thecut.com.

4. Gaby Cepeda, "Artist Profile: Shawné Michaelain Hollo-way," *Rhizome*, September 24, 2015, rhizome.org.

5. Term invited by artist Gordon Matta-Clark in the 1970s to describe his interventions made on physical buildings around New York City. In its most basic form, anarchitect-ure means "against architecture" and extended to other forms, such as poetry and music, as a means of refusing traditional or classicised standards.

6. Jack Halberstam, "Unbuilding Gender: Trans* Anarchi-tectures In and Beyond the Work of Gordon Matta-Clark," *Places*, October 1, 2018, placesjournal.org.

7. Paul B. Preciado, *Countersexual Manifesto: Subverting Gender Identities*, New York: Columbia University Press, 2018, p. 36.

8. Ibid, 37.

09 *Glitch Is Virus*

1. Jack Halberstam, "'The Wild Beyond,'" in *The Undercom-mons: Fugitive Planning and Black Study*, edited by Stefano Harney and Fred Moten, New York: Minor Compositions, 2013, p. 6.

2. Stefano Harney and Fred Moten, *The Undercommons: Fugitive Planning and Black Study*, New York: Minor Compositions, 2013, p. 152.

3. American Artist, "Black Gooey Universe," *Unbag*, 2018, unbag.net.

4. Ibid.

5. Artist Bio, americanartist.us.

6. Saidiya V. Hartman, *Scenes of Subjection: Terror, Slavery, and Self-Making in Nineteenth-Century America*, Oxford: Oxford University Press, 1997, p. 17.

10 *Glitch Mobilizes*

1. Russell Goldman, "Here's a List of 58 Gender Options for Facebook Users," ABC News, February 13, 2014, abcnews. go.com.

2. Caspar Heinemann, "Magic Work: Queerness as Remystification," 2014, available at docs.google.com/document/ d/1-d1RpWJ2nR4iN2BKEwfHdQFgdPqKW-a8q7O-1ZAiNltU.

3. Kimberly Drew, "Towards a New Digital Landscape," *Sightlines*, May 11, 2015, walkerart.org.

4. Alexander R. Galloway, *The Interface Effect*, Cambridge, UK: Polity Press, 2012, p. 140.

5. Sherry Turkle, *Alone Together: Why We Expect More from Technology and Less from Each Other*, New York: Basic Books, 2011.

6. Kimberly Drew, "Towards a New Digital Landscape," *Sightlines*, May 11, 2015, walkerart.org.

7. Shaadi Devereaux, "Why These Tweets Are Called My Back," *The New Inquiry*, December 19, 2014, thenewinquiry.com.

8. Ibid.

9. "Zoë Paul: La Perma-Perla Kraal Emporium @ Spike Island," *The White Pube*, May 13, 2018, thewhitepube. co.uk.

10. Elizabeth Méndez Berry and Chi-hui Yang, "Opinion: The Dominance of the White Male Critic," *The New York Times*, July 5, 2019, nytimes.com.

11. "What We Do," POWRPLNT, powrplnt.org.

12. "BUFU : BY US FOR US," bufubyusforus.com.

11 *Glitch Is Remix*

1. Thinking here of Maya Angelou's 1994 poem "Still I Rise."

2. Alex King, "Feel like a Cyber Slave? Meet Tabita Rezaire, Healer of Souls," *Huck*, February 1, 2018, huckmag. com.

3. Emily Siner, "What's A 'Glitch,' Anyway?: A Brief Linguistic History," NPR, October 24, 2013, npr.org.

4. Simone C. Niquille, Sam Wolk, and Jeff Witscher, "The Fragility of Life," *Possible Bodies*, July, 22 2017, possible-bodies.constantvzw.org.

5. Simone C. Niquille, Sam Wolk, and Jeff Witscher, "The Fragility of Life," *Possible Bodies*, July 22, 2017, possible-bodies.constantvzw.org.

6. Peta Malins, "Machinic Assemblages: Deleuze, Guattari, and an Ethico-Aesthetics of Drug Use," *Janus Head* 7.1, 2004, p. 86.

7. Simone C. Niquille, Sam Wolk, and Jeff Witscher, "The Fragility of Life," *Possible Bodies*, July, 22 2017, possible-bodies.constantvzw.org.

8. Associated Press, "George Zimmerman Judge Ponders Request To Use Animated Recreation," *Guardian*, July 9, 2013, theguardian.com.

9. Erin Donaghue, "George Zimmerman Trial: Defense Can't Introduce Animation of Fight as Evidence, Judge Rules," CBS News, July 10, 2013, cbsnews.com.

10. Zach Blas, Facial Weaponization Suite, 2011–14, zachblas. info/works/facial-weaponization-suite.

11. Ibid.

12. American Artist, *A Refusal*, 2015–16, americanartist. us/a-refusal.

13. Florence Okoye, "Decolonising Bots: Revelation and Revolution through the Glitch," Het Nieuwe Instituut, October 27, 2017, botclub.hetnieuweinstituut.nl.